HOW TO MAKE IT

HOW TO MAKE IT

25 MAKERS SHARE THE SECRETS TO BUILDING A CREATIVE BUSINESS

Erin Austen Abbott

CHRONICLE BOOKS
SAN FRANCISCO

Library of Congress Cataloging-in-Publication Data

Names: Abbott, Erin Austen, author.
Title: How to make it / Erin Austen Abbott.
Description: San Francisco : Chronicle Books, [2017]
Identifiers: LCCN 2016011931 | ISBN 9781452150017
Subjects: LCSH: Handicraft.
Classification: LCC TT145 .A33 2017 | DDC 745.5—dc23 LC record available at https://lccn.loc.gov/2016011931

Manufactured in China

Design by Kristen Hewitt

10 9 8 7 6 5 4 3 2

Chronicle Books LLC
680 Second Street
San Francisco, California 94107
www.chroniclebooks.com

This book is for all the makers, crafters, artists, and working creatives
who get up every day and pour their hearts into their work because
they simply love what they do. You are *Making It.*
And for my wonderful husband and son, Sean and Tom Otis,
who have supported me, always.
And for my mother, Dorothy. May I always carry on the tradition for her.

CONTENTS

MAKING IT

Some people follow their creative path as a hobby, while others are able to pursue it as a career, driven by a passion that they can't walk away from. What led them down the path to become a working creative? How did they get there, what hurdles did they have to jump? There are so many questions that we ask ourselves, and most start with the same one word: How? That's the question I want to answer with this book: How they made it.

My own creative path began at a young age. As a child, I used to rearrange my room monthly, always looking for a new way to display my things, never able to settle for the same old arrangements. As I got older, I began making mixtapes for friends filled with bands they hadn't heard, always seeking out what they didn't know they loved yet. Before eBay, in 1994, I worked in a vintage store, spending hours hunting for discarded treasures that would find a new home. In graduate school, I curated art shows, looking for artists that I knew were going to break out one day but hadn't been discovered. I found that curating and hunting for the undiscovered was my passion.

I worked in retail in high school and all through college, first at an art gallery in St. Petersburg, Florida, where I was put to the task of making a lot of the art we sold, then moving on to a vintage store in Tampa, where the art of the hunt was the name of the game. After college, I moved around, eventually winding up in Seattle, where I worked at a small art and design store in the Capitol Hill neighborhood. After graduate school, I toured with bands full time, working as their merchandising manager. Each day, we would drive into a new city, and after I set up my merch table, I would head out to explore. I would seek out the area of town with local restaurants, gift shops, vintage shops, and record stores. I would look for handmade items from local artists or 7-inch records of local bands. I would gather business cards and write down names of artists, with the hopes that I would carry them in my "one day" shop.

My previous experiences in retail, vintage sales, design, and merchandising all guided me to where I am today. I learned about what to look for and what customers were also looking for, about designers, and how to think about and look at design—more than I could have learned in school.

When I finally had my own store, I thought that was where it would stop, that I would share my finds with my customers and tell the artists' stories and that would be that. But the new craft movement was becoming such a force in the world of working creatives and the

handmade nation, and I felt I had to speak louder to be heard outside of Mississippi and the 187 square feet that encompasses my shop. I felt like more was needed than just selling their goods, but actually sharing their stories. In 2013, I began a series on my Instagram feed called Studio Stories, a place to share the faces behind the products. I wanted people to walk into my shop and feel like they were supporting a friend, not just another faceless company. For me, it has never been about being a giant store that makes thousands of dollars, but more about forming an engaged community—a community of people working together, supporting one another, while also helping others just starting out find their voice and create a brand.

This book expands upon Studio Stories by sharing not just the space and work behind the artists' products, but also revealing *how* they got to the place they are with their business. "I always knew I wanted to be an artist and I think I was just naive enough to not be too scared to pursue it," said Georgia-based painter Britt Bass Turner. Some makers in the book talk about how they decided to take the leap to being a self-employed working creative, while others share tips they've learned to help them stay on top of the business side of things.

I wrote this book to share lessons we've all learned along the way and the routes we've taken to grow our small, creative businesses. Whether you are an artist just starting out or someone who's been a working creative for years, I hope each chapter will give you

perspective into the life of a small business owner. I have grown as a shop owner by writing *How to Make It,* learning valuable information that I, too, can apply to my business. That is what I want this book to do for you. I hope this will help you with managing the day-to-day and give tips and tricks that seasoned artists have figured out and want to share with you.

One of the great pleasures in writing this book was finding that so many creative people have fun DIYs that are doable, quick, and easy. The twenty-five projects in this book will inspire you in your own business, while also leaving you with a little piece of art. Projects range from making your own watercolor paint to fabricating a simple brass bracelet.

From the firsthand industry knowledge, to the inspiring playlists, to the carefully selected photographs shot in natural light, I wanted to create a feel for each space that would allow you to feel like you just walked into the studio. *You* can attain these spaces and *you* can make it.

How to Make It is just the beginning of the conversation. We have so much to learn from one another as we follow our creative paths. Let's all be in this together. There are so many people who are living as working artists, supporting these artists, and shopping the handmade movement daily. Without you, none of this would be possible.

—Erin Austen Abbott, writer and photographer

BLUE DELTA JEAN CO.

TUPELO AND OXFORD, MISSISSIPPI

NICK WEAVER *and* JOSH WEST
DENIM DESIGNERS

Starting a company unlike any other is both daunting and risky. But for Josh West and Nick Weaver their denim business has been so rewarding, both personally and professionally, that the risk paid off. Despite neither having a background in fashion or manufacturing—Josh worked in real estate investment and Nick worked in tech—they have managed to grow their bespoke denim line to be sold in over thirty-five states and several countries, while still keeping all the manufacturing in-house.

"I feel that now I am confident enough to admit when I am wrong or when I don't know the answer." —Josh

A CONVERSATION WITH NICK WEAVER AND JOSH WEST

How have you grown as a businessperson?

Josh: I feel that now I am confident enough to admit when I am wrong or when I don't know the answer. In the early days of Blue Delta I felt like, as the leader, I needed to always have an answer. This thinking led to a lot of wrong answers. I've also been working on knowing when to "call in the experts." I am a generalist and have always fought the expert ideology that my generation bought into. In doing this I have sometimes waded into waters that were way outside of my territory. As consulting becomes more a part of our business, I have had to fight the urge to dive in and have learned to call in experts early and often.

What resources do you turn to, both online and in print, to gather current business advice?

Nick: I follow many individuals. I read their books and bios, track current companies and deals they closed. My heroes have quickly changed from Brett Favre to Warren Buffett. I was reading about how Buffett started his first gumball business, and his first purchase was another gumball machine. He kept it simple. It worked. I read as much as I can on successful people and how they made their money. I also reach out to business owners locally and visit them to learn their own stories. Very inspiring.

Josh: All my personality surveys put me right in the middle of the introvert/extrovert column, so reading is a good (quiet) escape for me. I like to read almost exclusively nonfiction. I have also learned a great deal from hands-on experience. Some of my best lessons in life have been failures. My favorite business resource books are *Rework, Good to Great, Basic Economics, The Checklist Manifesto,* and *Thing Explainer.*

How did you stay focused and original when you were starting out?

Nick: The plan Josh drew on a napkin (pick your thread, denim, and cut) was so original that it removed us from the design process. All we had to do was provide high-quality goods to our customer. This kept us from having to create trendy products, and instead we made something timeless. Blue Delta's Oxford studio provides more options in denim than most stores that have larger storefronts. This napkin business model from the beginning has kept us focused and original.

How do you see your brand growing in the next five to ten years?

Nick: In the next five years, I see Blue Delta established in cities like Charleston, Savannah, and Austin—cities rich in culture, history, and creative minds, much like Oxford. I see the brand maturing in quality, first fits becoming a common occurrence, and several more denim options becoming available to our customers. I hope we continue to strive to keep our innovation and customer experience at a high level. In the

next ten years, I hope that Blue Delta will be a brand that makes Mississippi proud, one that people associate with Mississippi roots. I hope Blue Delta will have played an important role in the "Made in America" movement, and that our craft inspires other brands to continue making great products in America.

A DAY IN THE LIFE

Nick: A typical Monday for me begins at 4 a.m.
I use this time to read business articles and
motivational quotes and look at news on
upcoming technology. I read anything from
fashion to technology until about 5 a.m., then
I'm on my way to Tupelo to the manufacturing
facility. I meet with Josh and we like to get
organized for the week. We first tackle the
schedules, then discuss customer service,
which leads into the budget. It's guaranteed
that my ADHD will come out at some point
during our morning meetings, and we often
trail off to discussing app ideas and partner-
ships and who knows what else. At the man-
ufacturing facility, we cut denim and trim
finished jeans, I grab what needs to go to the
Oxford studio, then I head back and open
the studio for private appointments and run the
store from 11 a.m. to 5 p.m. In between, I'll
talk my butt off and answer anywhere from
thirty to sixty phone calls. When 5 p.m. rolls
around, I'm likely still having meetings on the
phone. Normally I rush home to steal as many
hours as I can with my son. Around 7:30, he's
out, and I'm scheduling calls for the next day.

YOUR FAVORITE JEANS

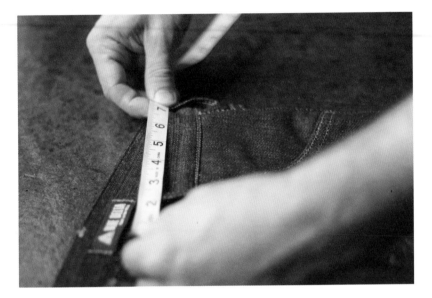

Here's a tutorial on how to measure your favorite jeans, to know exactly how to have them re-created.

SUPPLIES
· Your favorite pair of jeans
· Tape measure
· Paper and pencil

DIRECTIONS
1. Make sure your jeans are lying flat for all measurements, that the measuring tape is taut, and that the jeans are buttoned and zipped for the most accurate readings. Have your paper and pencil handy for jotting down the measurements.

(continued)

2. Waistband: Measure along the bottom inside of your jeans waistband, and run your measuring tape around the band.

3. Seat and depth of seat: With the jeans lying flat, measure across the jeans, approximately across the bottom of the curved fly stitching (seat). From this point, measure the distance to the top of the waistband (depth of seat).

4. Front rise: Measure from the crotch seam to the top of the waistband on the front.

5. Back rise: Measure from the crotch seam to the top of the waistband on the back.

6. Thigh: Measure across the thigh right below the crotch seam, the broadest part of the thigh.

7. Knee and depth of knee: Measure 13 in/33 cm down from the crotch seam, and then measure across the jeans leg.

8. Leg opening: Measure across the bottom leg opening of the jeans.

9. Outseam: Measure from the top to the bottom of the jeans for the total length.

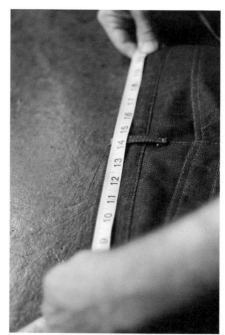

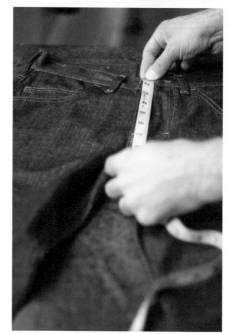

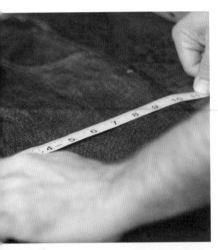

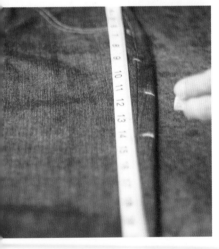

MAKE ME A MIXTAPE: INSPIRING SONGS FROM THE STUDIO

From Josh
1. Kings of Leon, "Pickup Truck"
2. Marshall Tucker Band, "Can't You See"
3. Van Morrison, "Into the Mystic"
4. Waylon Jennings, "Bob Wills Is Still the King"
5. Willie Nelson, "Pancho and Lefty"

From Nick
6. Jason Isbell, "Cover Me Up"
7. Dawes, "All Your Favorite Bands"
8. Leon Bridges, "Better Man"
9. Wood Brothers, "Maryann"
10. Andrew Bryant, "The Free"

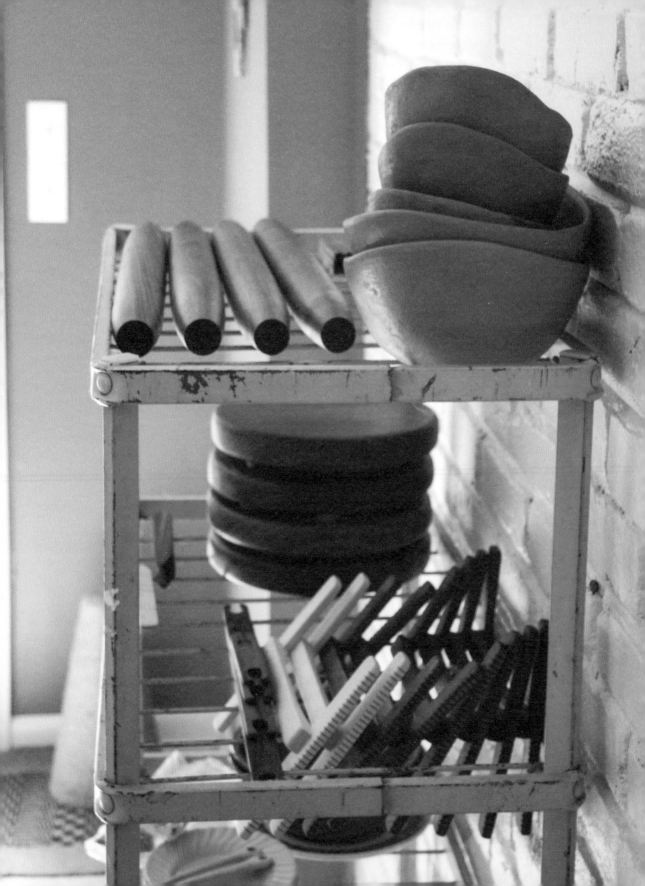

BOARD AND BREAD

NASHVILLE, TENNESSEE

EMILY BROCK
WOODWORKER

Emily Brock's grandfather and father were both woodworkers, and although it might have seemed like a natural next step for her to become a woodworker, it took a while for Emily to make the leap. Emily was working full time as a graphic designer in Washington State when she felt the pull to become a self-employed, working creative. Now living in Nashville, where she shares a workshop with her father, she has made a name for her art in Board and Bread.

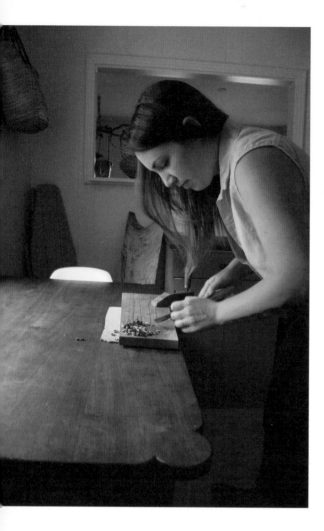

"I wouldn't change how things panned out for me, but I would always advise anyone wanting to scale back or quit other jobs to hang on as long as you can, ideally until your monthly income from your new business becomes consistent (and livable) at least three months in a row." —Emily

A CONVERSATION WITH EMILY BROCK

What have been the biggest hurdles in growing your business to where it is today?

Woodworking is one of those hobbies or professions that require a serious amount of tools. Depending on what kind of project you are working on, you could use anywhere from two or three to fifty tools to get the job done. Also important to consider is buying tools that will last, not just what you can afford or what the cheaper option is. Most every tool is an investment, and then on top of it you have to have a place to put all the tools and dust collection to keep your tools and lungs clean. At first I was just working with a band saw and a few inexpensive hand tools to make spoons and cutting boards. I had no dust collection and I was working out of an old canning shed filled with spiders and very little light. This could only go on for so long before I either needed to get a business loan or become stagnant in my work. In lieu of those options, we decided to move across the country again to Nashville. In Nashville, I was able to work out of my dad's workshop, which was fully equipped for most any project I'd want to do, and save money toward my own shop.

Did you read business books, learn from hands-on experience, or get another form of business advice when first becoming a working creative?

I am always learning about business. One thing they definitely don't teach you when you get a liberal arts degree of any kind is how to actually run a business. I feel so sad and overwhelmed sometimes about all the talented artists out there (including myself) running around with no real education or knowledge of how to turn their work into a functional business. Why isn't a minor in business required? I know I would have totally hated it at the time, but I'd be grateful for it now! Until I hired an accountant I had no idea what I was doing. I found someone who works exclusively with small business owners like myself, and all I can say is that I wish this had been one of the first things I had done when I started my business. It does cost money, but it is totally worth it.

How did you stay focused and original when you were starting out?

When I first got started the method I used for creating new designs and work was to go to a lot of yard sales and thrift stores. I'd buy all kinds of spoons, knives, old cutting boards. I'd really look at the lines of all these old pieces and see what worked and didn't work, what I liked and didn't like about the functionality of the tools, and then take it from there. I think when you need some creative inspiration it's always a good idea

to go back to the basics. People have been carving spoons for hundreds of years. It is important to consider what came before you and see what works about it and how to make it better or more appealing.

A DAY IN THE LIFE

One of the best parts of working for myself is
that more often than not I don't wake up to
an alarm. I usually get up at 8:30 or 9:00,
which is definitely morning in my opinion. My
fiancé and I both have pretty flexible sched-
ules, so we usually try to have a nice breakfast
together at home. We make coffee and cook
together; it's my favorite way to start the day.
After that I usually get on the computer and
answer emails for a while, print out any ship-
ping labels I need for the day, and try and get
my plan for the day organized. Depending on
what I'm working on, I'll usually either go to
my workshop and work on orders, or I'll stay
at home and work in my sanding/shipping
studio that is behind our house. Every day is
different: sometimes I'll end up sanding and
finishing pieces through 10:00 or 11:00 p.m.,
or I'll wrap up early at 6:00 or 7:00 p.m. and
we'll go to the gym and then cook dinner.
After that I usually opt for chill time spent
watching some Netflix and hanging out with
our kitties.

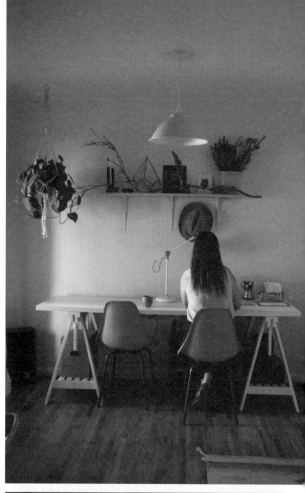

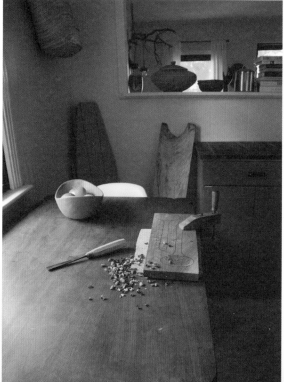

HOMEMADE
WOOD BUTTER

You don't have to be a professional woodworker to protect your handmade wooden items, such as spoons and cutting boards. This easy recipe will preserve the life of these items for years to come.

The conditioner is made of two basic ingredients: beeswax and mineral oil. My general rule of thumb for the proportions is 2:1, two parts mineral oil to one part beeswax. Unless you're making a large batch for gifts, this probably means you need about 1 cup of mineral oil and ½ cup of beeswax to make enough to last you several months.

SUPPLIES
- Pure mineral oil
- Beeswax pellets or small bricks, chopped
- Small saucepan or microwave-safe container (I use one exclusively for this because it's hard to clean afterward)
- Wood bamboo skewer or Popsicle stick
- Weck or mason jar for storage (optional)

(continued)

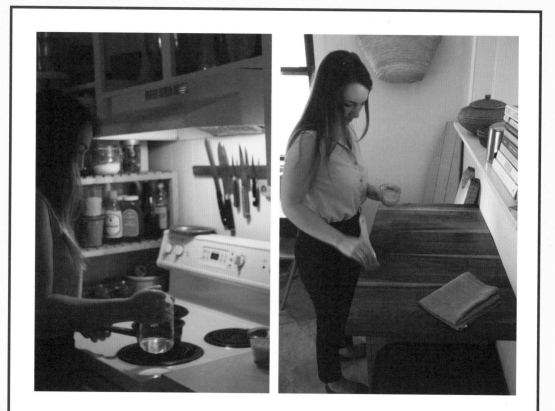

DIRECTIONS

1. Combine the mineral oil and beeswax in a small saucepan over medium to medium-low heat, or if using a microwave, zap in short increments.

2. Once the beeswax has dissolved completely in the mineral oil, give it a good stir with your wooden stick and pour into your pretty glass jar.

3. Once cooled to a pasty, creamy, solid consistency, screw on your lid.

4. Warming your conditioner isn't required to use it, but I always re-liquefy my wood butter and then apply it liberally on my wooden pieces with a pastry-style brush once it is starting to solidify again. The warm wax and oil helps open up the pores of the wood to better receive the finish. I let all pieces sit for at least 15 minutes before buffing out the extra wood butter with a soft cotton or microfiber cloth.

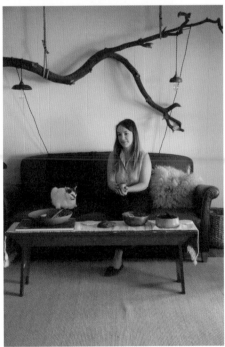

MAKE ME A MIXTAPE: INSPIRING SONGS FROM THE STUDIO

1. Robyn, "Dancing on My Own"
2. MGMT, "Electric Feel"
3. Miike Snow, "Animal"
4. Daft Punk, "Get Lucky"
5. CHVRCHES, "The Mother We Share"
6. AWOLNATION, "Sail"
7. Twin Shadow, "Five Seconds"
8. alt-J, "Fitzpleasure"
9. Portugal. The Man, "Modern Jesus"
10. Shovels & Rope, "Kemba's Got the Cabbage Moth Blues"

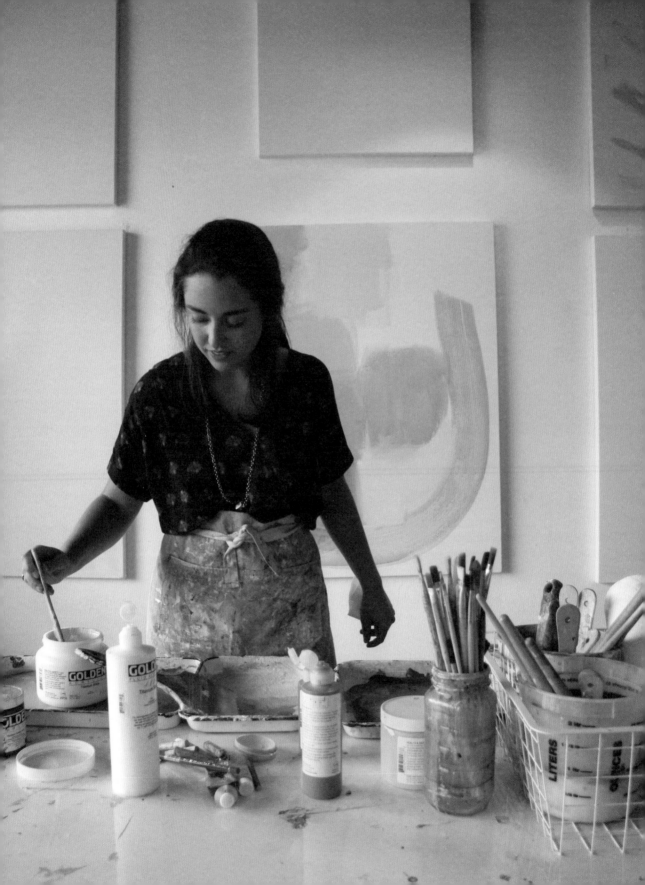

3

BRITT BASS TURNER

ROSWELL, GEORGIA

BRITT BASS TURNER
PAINTER

Britt Bass Turner has always had a passion for creating and an eye for aesthetics, and making art her life's work is all she ever wanted for herself. After graduating from the University of Georgia with a BFA, she moved around, working in retail shops, decorating cakes, and being a nanny before taking the plunge to work for herself as a full-time artist. Britt's art is sold in dozens of brick-and-mortar shops around the world, with her work ranging from original paintings and prints to pillows, phone cases, cards, notepads, and more. She hosts regular painting workshops at her Roswell-based studio, named Studio Studio.

"I always knew I wanted to be an artist, and I think I was just naive enough to not be too scared to pursue it." —Britt

A CONVERSATION WITH BRITT BASS TURNER

How did you stay focused and original when you were starting out?

I have always focused on making my best work, and lots of it. I don't get bogged down by the failures. I keep going. I'm excited about the next piece before I finish the current one. The more work I make, the more I grow into my own style and voice as an artist.

What keeps you going each day as a working creative?

My curiosity—the potential of what I can paint today, tomorrow, five years from now, is endless. I'm excited to see what comes next!

Do you read business books, learn from hands-on experience, or get another form of business advice?

Thanks to my brother-in-law and husband I now read business books and blogs (e.g., *The War of Art,* Marie Forleo, Tim Ferriss, Donald Miller, Jeff Shinabarger), but I learn best by doing, so I would say the majority of my business acumen is a by-product of hands-on experience. Every day brings new challenges, and I've learned to roll with the punches, learn from my mistakes, and pick up what works. I really enjoy learning and gathering lots of information that I then funnel into different areas of my life. I don't see hard lines between my business and personal life; it's more holistic for me,

so really I'm constantly filing away all the information I intake every day in my brain and putting aside tidbits that I think would be helpful for "work." I'm currently reading *Girlboss* along with the rest of the world, but I have Tom Rath's *StrengthsFinder 2.0*, a *Garden & Gun* magazine, a book of Sudokus, and *Kinfolk Table* on my nightstand, too—I think they are all helpful to my business in different ways!

What have been your biggest hurdles and rewards in growing your business?

My greatest challenge over the years has been discerning when to say yes and when to say no in relation to staying on track with big-picture goals. There are only so many hours in a day and only so many paintings I'm capable of producing in a given time. It's been a challenge for me to stay focused on what is most important for the business while balancing what best lines up with personal goals as well.

The rewards have been all of the relationships that have formed over the years. It's been such fun to be a part of a greater creative community in all of the cities I've lived in as well as through social networking. I love being able to interact with my customers and see my works hanging in their homes—it is a nice full-circle moment when a painting leaves me and finds its new permanent home.

Can you offer a way to say yes and no to different projects?

I have found saying "no" to be one of the most rewarding parts of my business and to have the most long-lasting effect on my progress as an entrepreneur. I have a hard time saying no, because every new opportunity or collaboration always sounds like so much fun and I genuinely want to always say yes! I have put forth a few boundaries with the help of my employees to draw the line between our yeses and our no's in advance, so when opportunities arise we already have an answer based on the request. For example, we can only donate a certain amount of paintings to nonprofits, auctions, etc., every year, so once we have reached our limit we now have an email template made in advance to kindly decline the offer due to our reached limit. Jeff Shinabarger's book, *Yes or No,* is a great read and really helped define this concept for me. Jeff describes decisions as transactions—every yes to x is a no to y. This simple thought reminds me that these decisions are based on the future success of my business and that makes it a lot easier to say no!

A DAY IN THE LIFE

I wake up between 7:00 and 8:00 a.m., eat breakfast and have my coffee, answer a few emails at home, try to squeeze in some yoga on a good day. If I don't have any errands or appointments, I get to the studio around 10:00. Once a week my small team will get together to discuss any new marketing ideas, web initiatives, and overall to-dos for each member. After making sure the team is good to go on their tasks, I'll start painting, usually around noon. I'll paint until 4:00 or 5:00. If we are really busy, sometimes everything gets pushed back and this looks more like 7:00 or 8:00. This ideal schedule only actually happens one or two days a week because there are always meetings, photoshoots, pop-up shows, etc., that break up our day. Once we leave the studio we like to take our Boykin spaniel, Birdie, to the park or to a friend's house to play. My husband, Ren, and I will make dinner, read, meet up with friends for a drink, try a new restaurant, or see a show. Ren likes to start planning the next day, but I make a point to leave work at the studio when we leave; otherwise I'm up all night answering emails and thinking of to-dos (let's be honest, I do this anyway sometimes, too!).

YEARBOOK ART

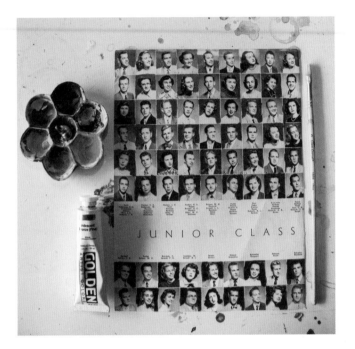

This DIY is great when you need a new piece of art for the walls or you want to make a thoughtful housewarming gift for a friend.

SUPPLIES

- Gold acrylic paint, or any color you prefer, and paintbrush
- Black-and-white photograph (we used a page from an old yearbook from a thrift store)
- Camera
- Large frame

(continued)

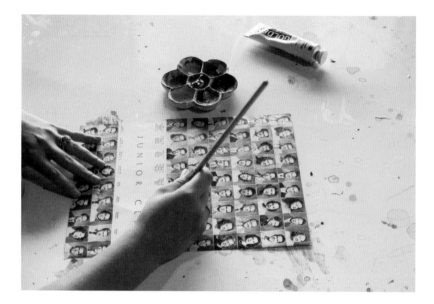

DIRECTIONS

1. Paint on the old photograph using acrylic paint.

2. Photograph the painted image in bright natural light.

3. Crop and size the digital image to fit the desired frame size. The one pictured is 18 by 24 in/46 by 61 cm.

4. You can print at an office supply store using the blueprint oversized printing option.

5. Once you have the large-format print, you can touch up with acrylic paint to add any extra layers or texture.

6. Frame and voilà! You're done!

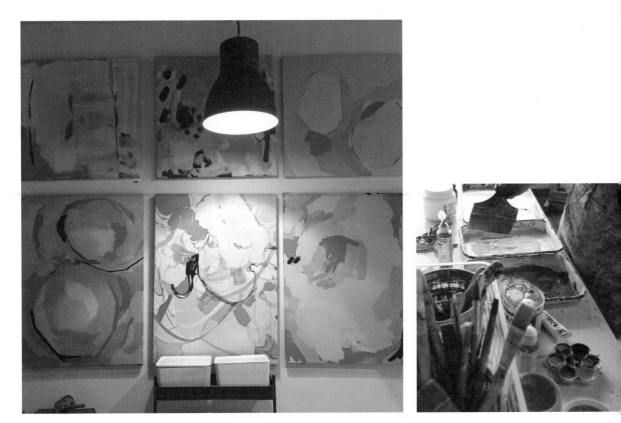

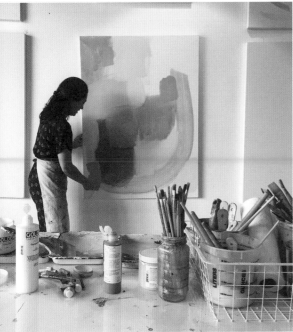

MAKE ME A MIXTAPE: INSPIRING SONGS FROM THE STUDIO

1. Nikki Lane, "Right Time"
2. Kings of Leon, "Beautiful War"
3. Shovels & Rope, "Birmingham"
4. Katy Perry, "This Is How We Do"
5. St. Paul and the Broken Bones, "Like a Mighty River"
6. My Morning Jacket, "Wordless Chorus"
7. Drake, "0 to 100"
8. Dusty Springfield, "Son of a Preacher Man"
9. Bruno Mars, "Uptown Funk"
10. Alabama Shakes, "Hang Loose"

CAROLINE Z HURLEY STUDIO

BROOKLYN, NEW YORK

CAROLINE Z HURLEY
PAINTER

When Caroline Z Hurley graduated from Rhode Island School of Design (RISD) with a degree in painting, she never imagined she would one day become head designer in a self-made business. After RISD she moved from job to job; she worked at an architecture firm, a PR firm, a design firm, and as a personal assistant in LA and NYC. Nothing really seemed to be the right fit until she found herself teaching art to preschoolers—that's when everything finally fell into place. Channeling the inspiration she felt from the children she was teaching led Caroline toward re-creating their bold curiosity and being completely present and open in her own work. Caroline took that energy and started Caroline Z Hurley Studio.

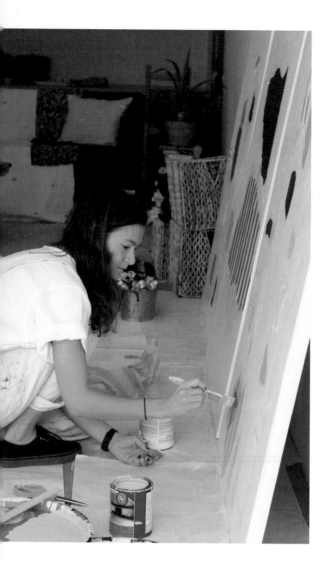

"I have this tendency to want to do everything, and I have to actively work on creating boundaries for my brand."
—Caroline

A CONVERSATION WITH CAROLINE Z HURLEY

Did you read business books, learn from hands-on experience, or get another form of business advice?

I always had entrepreneurial ambitions. I just learned by doing and messing up and then fixing the problems that I had created. I don't have any close mentor to speak of, but I love the idea of that! Maybe I should find one. One of the coolest things about this age we live in is that you can just reach out to just about anyone you respect and ask for advice.

How have you grown as a businessperson?

I have learned that the quality I must possess as an entrepreneur is that I have to just *know* everything will be okay. And I have to know that for every problem that arises I will figure out the answer and that nothing is too difficult to solve. Running your own biz is so hard and it's so easy to give in to the stress, but it's so important to remember why you chose this path and to say, "I can choose the vibe for today!"

What do you find most inspiring about your space?

I love that I get to open my door and interact with the people who purchase my things and I also love that I can close the blinds when I need solo creative time. I am more of an introvert, but I find that since I work alone most days it's really nice to

have a couple of new kinds of people breeze through the space for some new energy.

How do you stay true to your brand?

My brand started when I was teaching preschool, and what those kids brought to my brand is everything. I love their boldness and simplicity. I try to carry a sense of naïveté and playfulness while also staying true to my favorite thing to do in the world, which is to be cozy.

As your business expands, how do you decide which direction to grow in? What guides you?

Instincts always guide me. I want my business to grow, and I make plans to see that

through, but I also listen to my body. I have a five-year plan, but I also don't let that plan get in the way of something new coming along and having my brand take a turn if it feels right. I always use this phrase I came up with in high school for a project when trying to define what serendipity means: "Be strong and set on the goal, but creative and flexible on the journey." That's basically the theme of my life, and it has served me well so far!

A DAY IN THE LIFE

Wake up, meditate, stream-of-conscious writing for ten minutes, make tea, walk to studio, make a list of what needs to be done that day for my business, proceed to cross those things off (those things include: responding to emails, designing collections, sourcing material, drawing, and painting), leave studio at around 6:00 or so and either go home to cook dinner or meet pals out for a drink!

BLOCK-PRINTED SCARF

Take this idea and run with it. . . . You can make napkins, totes, tea towels, and more with these simple directions. What seems like a simple cutout on your block is actually the design that will bring the fabric to life and give it the design of your choosing. Start with a simple shape or pattern and move on to more detail once you feel comfortable with the craft.

SUPPLIES
- Pencil
- 4-by-6-in/10-by-15-cm block of E-Z-cut rubber blocks (or if you're comfortable working with linoleum you can use a 4-by-6-in/10-by-15-cm block of lino-leum, ¼ in/6mm thick)
- Steak knife
- Paintbrush
- Fabric paint
- Linen (iron the fabric before starting)

(continued)

DIRECTIONS

1. With a pencil, draw a shape on the rubber block.

2. Carve out the shape with a sharp steak knife.

3. Dip the paintbrush into the paint and apply a thick layer of paint directly onto the rubber stamp.

4. Press the stamp down onto the linen, bear down hard, and then slowly lift up.

5. Repeat in whatever pattern you like!

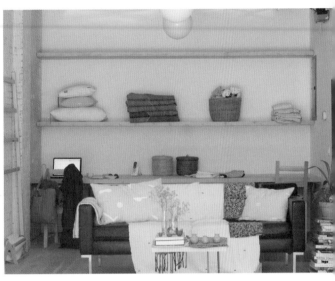

MAKE ME A MIXTAPE: INSPIRING SONGS FROM THE STUDIO

"Any songs by these bands will do . . . "
—Caroline

1. Leon Bridges
2. Amy Winehouse
3. The National
4. The Ryde
5. Local Natives
6. Haim
7. Phosphorescence
8. My Morning Jacket
9. Bob Dylan
10. The Melodians

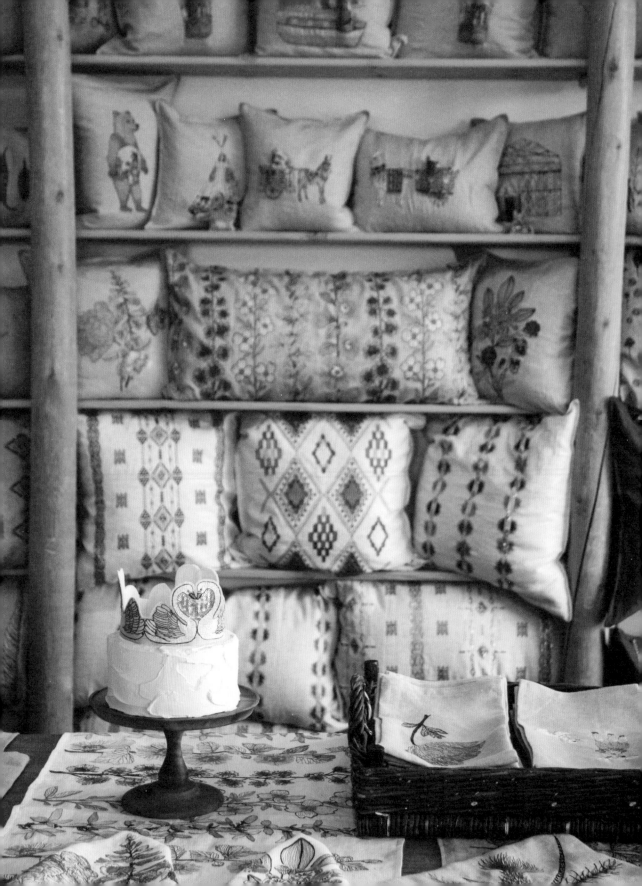

5

CORAL & TUSK

BROOKLYN, NEW YORK

STEPHANIE HOUSLEY
TEXTILE DESIGNER

After getting a BFA in textile design from RISD, Stephanie Housley started Coral & Tusk as a side business in 2007, while working as a textile designer for a fabric mill based in India. She's since grown it to be a powerhouse in the world of fabric and design. Blending the love of travel and nature with fabric and illustration in a way that hadn't been done before, Stephanie has secured her thriving business as an innovator of high-end usable art.

"For better or for worse, I am guided by my gut at all times!" —Stephanie

A CONVERSATION WITH STEPHANIE HOUSLEY

As your business expands, how do you decide which direction to grow in? Add more space or employees or products? What guides you?

I choose to run my business collaboratively. No designer or business owner works in a vacuum. The success of any business has as much to do with the collective support of the team following through on my vision as the vision itself and the quality of the final product. And so this idea has contributed to the success of my business in that I respect and admire my team as much as they do me. This helps ensure that the vision I bring to the table is understood, acted upon, and often fine-tuned or improved by these wonderfully talented people. Also, while I explore different themes each season, the heart of every collection is the same: my awe and respect for the art and craft of native cultures, as well as my deep love for the animal kingdom. I am always thinking about next steps, though, and trying to be very open to all of the different paths we can take. Sometimes it feels hard to know what all those are. We spend so much of our time reacting to what we have to do versus initiating future opportunities. For better or for worse, I am guided by my gut at all times!

How have you grown as a businessperson?

I think the fastest way to sum it up is that I used to freak out and completely shut down when my husband would ask me about projections and we would talk about budget and anything that was to take place in the future. It took me years of growing my business while still working full time at a really demanding job before I chose Coral & Tusk to focus on. I am super risk averse and never wanted my own company—I was happy working with the false sense of security provided by a job with a company that you do not own. When I finally decided to make the change, all those scary questions became necessary pieces of information for me to develop and think about in order to really own my business and command the direction. Some of those things remain daunting, but they no longer frustrate me as they once did. And now it's really nice to have a few years of being in business to truly start to analyze our numbers.

What have been the biggest hurdles to growing your business?

The biggest challenge we face is growing the company so that we can sustain and scale up as a business, while staying small-feeling in our relationships with all of our customers and continuing to create a product that feels super special, one that a person can feel a deeper connection with. Our products require a huge level of care and attention to detail, and we do not compromise on that. We are very selective about the stores we sell to in order to partner with stockists whom we can form a partnership and hopefully grow with and to make sure we do not oversaturate. That said, we are now faced with making more targeted outreach so that people can find our products at their favorite local shop in areas where we are not otherwise represented.

How do you stay organized?

I make a lot of lists. I keep things separated on different clipboards. I talk about things a lot with my team and delegate. We have weekly meetings every Monday morning where we all discuss things on our plate. This is the best time for me to make sure things are moving along and getting addressed as they need to be . . . and if they are not, a perfect time where we are all together to collectively problem-solve and lend support. Over the years we've developed systems by trial and error. We are always open to continuing to further cultivate and tweak and improve them.

What's most important to you when sourcing?

Ease in communication, trust, reliability, and consistency. Capacity to grow production and dedication to stick with you during all types of times—busy or slow. Willingness to try things and flexibility to develop beyond the norm. Setting realistic expectations.

A DAY IN THE LIFE

In the morning, Paco, my dog, and I go to
Prospect Park for an hour and then drive
to our studio in South Williamsburg. Each
day brings different projects, and many of
them! If it is new collection development
time (which happens twice a year), it is filled
with researching, drawing, programming
embroidery files, designing, and prototyping.
Otherwise, I spend a lot of my time at the
studio working with each of the team mem-
bers individually on their projects so that they
continue to learn and grow and take all the
right next steps to further lead in their posi-
tions. I try to spend time answering emails,
working on business development, doing
inventory assessments, communicating with
our workshop in India, and a huge variety of
things that unexpectedly crop up. At lunch we
all take a break and eat together. The team
leaves at about 6:00 p.m. and I stay later to
design and work. I meet my husband at home
for dinner and then try to get as many emails
done as I can before bed. Sometimes we just
relax and watch TV, but usually we are both
working because we are both small business
owners!

EMBROIDERY

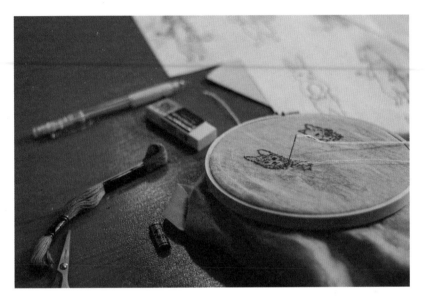

Bring the whimsy and cleverness of Coral & Tusk home to make your own individualized piece of art.

SUPPLIES
- Computer and printer
- Tracing paper
- Material you want to embroider on
- Carbon paper—navy blue is the best—such as from a receipt book
- Ballpoint pen
- Embroidery hoop
- Needle
- Colored embroidery floss

DIRECTIONS
1. Select your design based on a template of your choice and print. I advise customizing your template to make it individualized.

2. Create your final composition on tracing paper, tracing over the template paper.

3. Place the material you want to embroider on a clean, dry, flat, hard surface.

(continued)

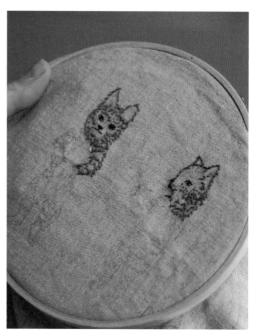

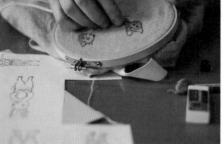

4. Select the exact area you want the embroidery.

5. Place a piece of carbon paper on that area.

6. Place your completed design on top of the carbon paper.

7. Using a ballpoint pen, trace the drawing. Make sure you are applying enough pressure! Lift a corner to confirm, but be sure not to shift the location of the drawing so that everything stays on register.

8. Once the drawing is complete, place the design face-down in the center of the larger part of the hoop. Put the small part of the hoop on top and tighten.

9. Choose the floss color you want to start with. Cut a piece of floss about 30 in/76 cm long. Separate out and use two of the six individual strands from the floss length. When you do detailed facial features, use only one of the six strands of floss.

10. Now begin to stitch! Trace the drawing with thread.

11. The fabric may become loose in the hoop, so be sure to adjust to keep the fabric taut.

12. Once complete, take the hoop off and enjoy!

MAKE ME A MIXTAPE: INSPIRING SONGS FROM THE STUDIO

"I am not great with song titles, so I will say nine musicians and one radio station that I like most of what they do!" —Stephanie

1. Gillian Welch
2. Black Sabbath
3. Beyoncé
4. Johnny Cash
5. Tom Petty
6. Fleetwood Mac
7. Mary J. Blige
8. National Public Radio
9. Loretta Lynn's album *Van Lear Rose*
10. James Carr

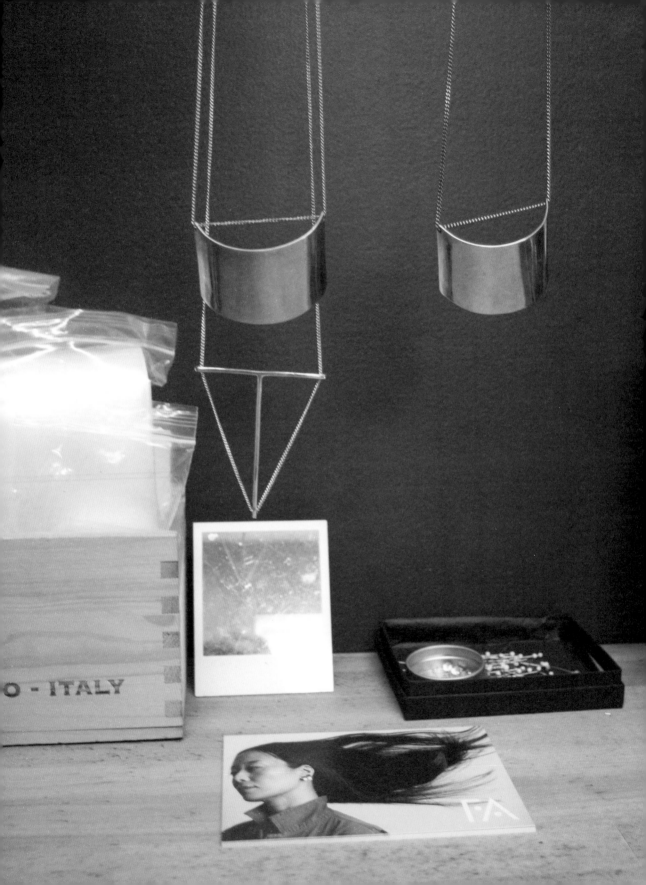

FAY ANDRADA

BROOKLYN, NEW YORK

FAY ANDRADA
JEWELRY DESIGNER

Fay Andrada never planned on starting her own business. But when the recession of 2008 hit, it was hard to find work in her chosen field of graphic design, so she decided to make what she liked: jewelry. Through word of mouth, she got more and more orders and eventually her work turned into a full-fledged line of handmade jewelry. In 2009, Fay Andrada, the brand, was born. What propelled things forward so quickly, in growing her business, was that she knew how to build and maintain a website, basically in her sleep. That helped spread the word of her new line of minimalist jewelry faster than if it had been a more organic process.

"Running a creative business leaves surprisingly little room for creativity." —Fay

A CONVERSATION WITH FAY ANDRADA

What have been the biggest hurdles to growing your business?

I have attention deficit disorder, so self-employment has been a huge challenge. I have many systems in place to help with concentration and time management, but it's not something that will ever go away. My advice to anyone starting out in a similar situation is to keep other people involved as much as possible. For example, my work space is located within a community of other design studios. There is a communal energy that helps me with day-to-day accountability; since I have no boss, this is a fairly effective way to trick my mind into thinking I do.

How do you stay true to your brand?

I design pieces I want to wear.

What would be a dream collaboration?

Fay Andrada x Denise Huxtable.

How did you stay focused and original when you were starting out?

It was a financial and creative necessity to keep my materials and tools to a minimum. Resourcefulness is one of my strengths. I would design pieces to wear out that night and if I only had a couple gauges of wire, some sheet, four hours, and a hammer, my creative challenge would be pretty clear cut. As my personal style evolved, the collection would parallel.

Tell me about your downtime; do you take on another form of creativity when not running your business?

Running a creative business leaves surprisingly little room for creativity. I usually spend my downtime thinking of new designs or letting my brain rest completely, while I unwind with food and wine.

A DAY IN THE LIFE

Rush through, but enjoy family breakfast.
Turn closet upside down. Walk two blocks
to work with my dog. Manage email. Think
about lunch way too long. Make jewelry.
Go home to wine, dinner.

HAND-FORGED BANGLE BRACELET

Make your own brass bracelet without being a jewelry maker. This simple bracelet is timeless and perfect for day to night.

SUPPLIES
- Wire cutter
- Metal wire (brass and copper are available at most hardware stores)
- A round form (make sure this is solid wood or metal, such as a rolling pin or hockey puck)
- Hammer
- Small pliers
- Sand paper

DIRECTIONS
1. With a wire cutter, cut a length of wire that fits you perfectly. The average bangle bracelet is about 7½ in/19 cm in circumference.

2. Wrap the wire around your form. Hammer gently and evenly around the circumference as well as on the top and bottom. The blows of the hammer will create surface texture and also strengthen the shape.

(continued)

3. Try the shape on your wrist, trim the ends, and hammer more if necessary.

4. Once your shape is final, open it slightly with your pliers, sand the ends until smooth and domed, then close again.

5. Once you've mastered the basic shape, use a longer piece of wire and your pliers to experiment with different closures, such as a hook and eye.

MAKE ME A MIXTAPE: INSPIRING SONGS FROM THE STUDIO

1. Irene Cara, "What a Feeling"
2. Madonna, "Secret"
3. Common, "Be"
4. Roxy Music, "More Than This"
5. Q Lazzarus, "Goodbye Horses"
6. Robyn, "Dancing by Myself"
7. M.I.A., "Paper Planes"
8. Nas, "If I Ruled the World"
9. Kanye West, "Celebration"
10. Bill Callahan, "Sycamore"

7

FERME À PAPIER

SAN FRANCISCO, CALIFORNIA

CAT SETO
PAINTER

With a BA in fine arts and an MFA in fiction, Cat Seto started Ferme à Papier (Farm to Paper) during a period of writer's block. While worrying about writing a "great novel," she took her fine art and turned it into her greatest narrative yet: creating a line of paper goods that tells a story on each card, an illustrated story. As her business has flourished, Cat has learned how to run a commercial retail space, sell a wholesale stationery line, and publish and license her artwork, all with dedication and an open mind.

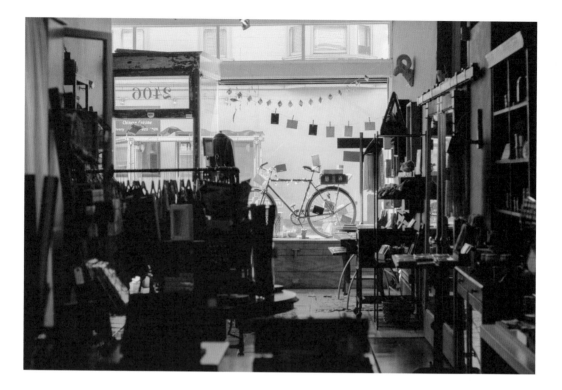

"Being a creative is a lifestyle choice. It matters less the size of my studio and more about whether I can wake up every day and have creative freedom of expression." —Cat

A CONVERSATION WITH CAT SETO

How do you stay true to your brand?

Ferme à Papier has a deep color palette; navy is our black. And there is a Paris-meets-Brooklyn vibe. I try to stay as true to that as possible while exploring different themes with each collection. My trip to Paris taught me about the everyday joys in life, and this is something that is found in the subjects of the work. I try to illustrate little moments . . . a couple embracing or a favorite pair of shoes. I return to Paris at least once a year and try to alternate seasons so that I can experience it in different environments. The trip is always a reminder of

being genuine to the brand and not forcing a look or style, but to let people and places guide the creative process.

Do you relate more as an entrepreneur or a working artist?

Both! I believe all working artists have an entrepreneurial spirit. I think being an artist today relies on being a part of a larger network of peers and colleagues who are motivated by a sense of industrious and creative fortitude.

How have you grown as a businessperson?

I have learned over and over again that whatever you do, make sure it is authentic. There have been times I have wanted to rush a product idea or venture into something for the wrong reasons. I have learned to simplify where I want to invest my energy and to make sure it rings true.

Did you read business books, learn from hands-on experience, or get another form of business advice?

I am a big believer in mentors. I have had great mentors, from high school art teachers to college poetry professors. So much of my business is in the making and doing of things and I could not have learned this solely from books or study. I remember cleaning bathrooms, mopping floors, and stocking shelves at a bookshop and tirelessly interning in the editorial department of a publishing company. These experiences taught me to stay humble, to embrace a strong work ethic . . . all of the things I liken to my "street MBA."

What have been the biggest hurdles to growing your business?

As with any creative business, it can be a big challenge toggling the on/off switch between creative and business to-do's. More often than I wish, a large part of my day is spent on the business end of things, leaving 1:00 to 4:00 a.m. as the only window when I can design and illustrate. I think it's important to really know your mission or goals and manage your growth according to those.

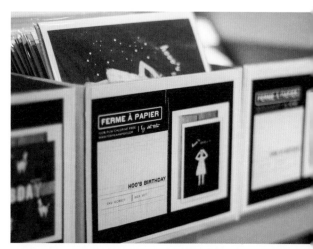

A DAY IN THE LIFE

After I drop my son off at school, I always start off a few mornings in my week with an intense kickbox workout. It clears my mind and helps me organize my goals for the week. Then it's straight to responding to emails, checking in with my studio and team, and seeing what the triumphs and fires for the day are. Design and creative work are always percolating throughout the day, but it isn't until everyone's asleep (including my son) that I can sit down on my couch and begin sketching or doing layouts. My days end late . . . very late!

WRAPPING PAPER GARLAND

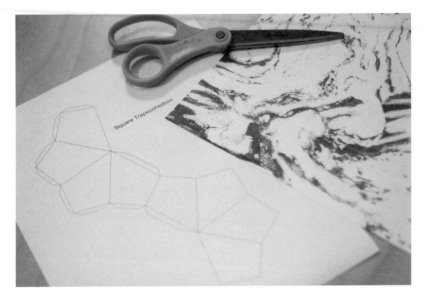

Never wonder what to do with scraps of wrapping paper again. These simple geometric paper creations could double as Christmas tree ornaments or a fun gift tag. Choose a paper you can cut down to a size that will fit through your printer. Make sure it's thick enough to hold its shape for folding but thin enough that it will go through a printer.

SUPPLIES
- Wrapping paper scraps
- Scissors
- Computer and printer
- Bone folder or clean butter knife or spoon
- Glue
- Double-sided tape (optional)
- Bright ribbon, twine, or yarn, for hanging (optional)

DIRECTIONS
1. Locate and download the template at fermeapapier.com/pages/diy-paper-geodes. We're doing a trapezohedron, and these steps will work perfectly with your favorite geometric shapes. You can make larger or smaller polyhedrons by scaling your design when printing.

(continued)

2. Print out the template on the paper of your choice.

3. Begin cutting out your design. Using scissors, cut along the exterior black line, making sure not to remove the flaps or panels. You can also cut the flaps into triangles to make it a little easier.

4. Score your lines with the bone folder. Depending on how thick your paper is, you may need to score the lines that will be folded.

5. Fold your lines and begin shaping. Start folding down the interior lines and the flaps, one by one. For this design, it will divide into two sections: the bottom with eight of the nine flaps and the top that they will adhere to. All flaps will be on the inside of the design, so they should be folded inward.

6. Glue the flaps to the panels. You'll be applying a light amount of glue to one flap at a time and pressing it together with precise pinches. If your hands are a little stiff or the design is a little small, you can also use double-sided tape. Begin with the middle flap on the side of the design that only has one flap. Connect it to the panel it is mirroring at its point, and you will end up with a four-petaled flower bud.

7. Connect the trapezoid panels. Using the same method, glue and press the rest of the flaps to form the trapezo-hedron. Your final panel will look like a door, which you can close and seal to finish.

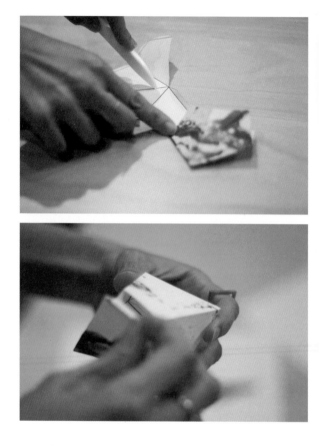

8. Repeat all the steps for each trapezo-hedron, let dry, and hang. With some bright ribbon, twine, or yarn, connect all of your polyhedrons and you've got yourself a garland!

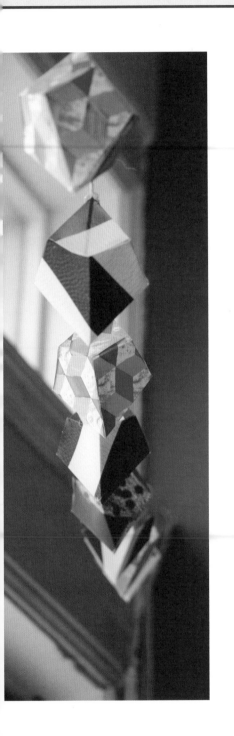

MAKE ME A MIXTAPE: INSPIRING SONGS FROM THE STUDIO

1. Lots of vintage French pop
2. Phoenix, "Everything Is Everything"
3. Phoenix, "Run Run Run"
4. Phoenix, "Alphabetical"
5. Phoenix, "Holdin' on Together"
6. Phoenix, "If It's Not with You"
7. Childish Gambino, "The Palisades"
8. Childish Gambino, "Retro"
9. Feist, "Mushaboom"
10. Feist, "One Evening"

FORAGE HABERDASHERY

MEDIA, PENNSYLVANIA

SHAUNA ALTERIO *and* STEPHEN LOIDOLT
NECKWEAR DESIGNERS

Married couple Stephen Loidolt and Shauna Alterio started their first business at the beginning of the handmade movement and they found themselves at the forefront of their field. In 2010, they created their second business, Forage Haberdashery, a men and women's necktie and accessories brand. Stephen and Shauna both have a BA and an MFA in fine art, and so they are often creating new and different bodies of work for their business, releasing one full and cohesive collection at a time, from ties to eyeglass cases to stationery. Ten years later, they have created a brand that is recognizable, sustainable, and successful. Now they are looking to slow down and focus on keeping their company small while preserving time to create a new line for the brand.

"We're not focused on how big we can be—we're constantly evaluating how small we want to keep it." —Stephen

A CONVERSATION WITH STEPHEN LOIDOLT AND SHAUNA ALTERIO

How have you grown as a businessperson?

Stephen: We've learned everything from the ground up. Growing the business in stages from a onetime pop-up shop to an online store to a wholesale line has allowed us to learn as we go.

Do you identify more as an entrepreneur or a working artist?

Shauna: Although both of us come from a fine art background, we're a pretty healthy mix of both. Stephen is hands on when it comes to making and I'm usually strategizing the next step.

As your business expands, how do you decide which direction to grow in? Add more space or employees or products? What guides you?

Stephen: This has been the trickiest part for us. We've done it both ways, and staying small is better for us. We've had employees, production studios, rep groups, and showrooms, but at the end of the day, we missed the personal connection. So now, we're not focused on how big we can be—we're constantly evaluating how small we want to keep it.

Tell me about your downtime: do you take on another form of creativity when not running your business?

Shauna: Since having kids, we value simple things more than ever. A weekend at the beach, lunch at the park, or coffee with friends—these are the things that recharge us.

What's most important to you when sourcing work, goods, and supplies for your company?

Stephen: We have had an amazing partner-ship with a production studio that has been hand making all of our goods for five years now. They're an all-women organization and that partnership has been a big part of our ability to go from a hobby to a true business. We've also had a rep group with six showrooms in the United States, and it helped us grow our wholesale business and get some really big accounts with major retailers, but at the end of the day that isn't where our hearts are. We really love working with other small businesses—that's what we're about.

What do you see for the next ten years for Forage?

Stephen: I hope we will have built a tree house for the boys, taken a few more Saturdays off from working to go exploring in the woods, and spent more Friday nights with friends than in the studio. I hope we are making things together and sharing them with our friends.

A DAY IN THE LIFE

Our two boys, Sawyer and Edison, wake us up at 5:00 a.m. After an early start, including toast, coffee, and getting them dressed, we divide and conquer. Each day is a mix of packing orders, developing the next collection, photographing new products, printing packaging, and communicating with vendors, shops, customers, etc. Each day usually ends with a race to UPS to get out an urgent, last-minute package. After dinner and getting the boys to sleep we head back into the studio for what hasn't been crossed off the to-do list. We try to shut things down by 1:00 a.m.

FABRIC EYEGLASS CASE

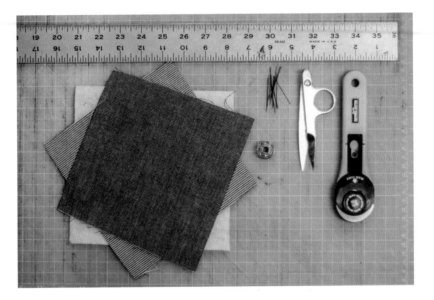

Protect your shades while still being stylish.

SUPPLIES

- Two 6-in/15-cm squares of fabric in contrasting styles
- 6-in/15-cm square of batting
- Pins
- Sewing machine or needle and thread
- Scissors

DIRECTIONS

1. Choose one piece of fabric for the outer panel and one piece for the inner lining.

2. Pin the pieces together like a sandwich, with the batting in the middle and each piece of fabric facing finished side out.

3. Fold the quilt sandwich in half, with the outer panel facing in. Sew around the perimeter of the fabric,

(continued)

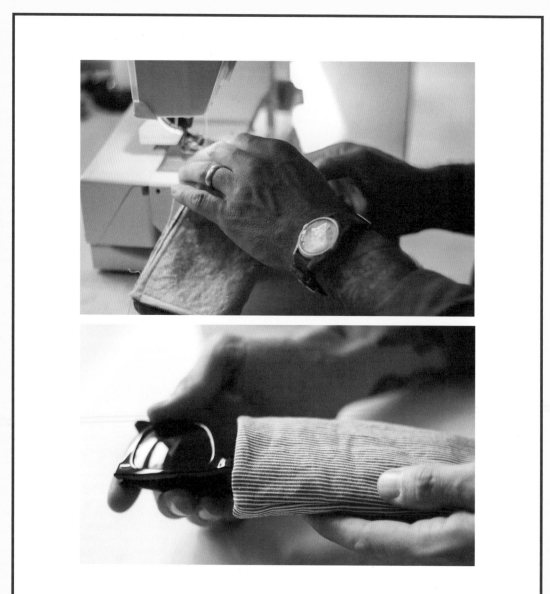

starting on one long edge, then moving around the short width and finishing at the end of the other long edge, leaving a ¼-in/6-mm seam allowance. Trim threads.

4. Turn the eyeglass case right side out.

5. Insert the glasses and enjoy.

MAKE ME A MIXTAPE: INSPIRING SONGS FROM THE STUDIO

1. Nan Phin Sar, "Mu Nohn Sah"
2. Yoko Ono, "Kiss, Kiss, Kiss"
3. Talking Heads, "Sugar on My Tongue"
4. Clothilde, "Et Moi, Et Toi, Et Soie"
5. Sonia, "Aquí en Mi Nube"
6. The Inner Space, "Kamerasong"
7. Lashio Thein Aung, "A Girl Among Girls"
8. Dead Milkmen, "Rastabilly"
9. Dara Puspita, "Lihat Adikku"
10. Shonen Knife, "Kappa Ex" (live)

GOLD TEETH BROOKLYN

LOS ANGELES, CALIFORNIA

JESSE LEVISON
PRINTMAKER

Jesse Levison grew up in Miami and attended the University of Florida for photography and art history. It was at UF that she took her first printmaking classes and fell in love with the medium. While still in school, she started screen printing her illustrations onto cards for friends on the side. Before she founded Gold Teeth Brooklyn, Jesse was juggling a few jobs, including work at a fine-art magazine and as a bartender. Not expecting it to go anywhere other than just be a fun hobby, her cards have garnered an overwhelming response. Jesse started her own business and now manages a team of several employees. Her products range from greeting cards to jewelry, ornaments, books, and tote bags.

"Sure, it can be wildly over-whelming at times. I work constantly, and I don't make an insane amount of money. But I wake up, and I get to be creative and push the fruits of my labor into the world, and I feel fortunate for that." —Jesse

A CONVERSATION WITH JESSE LEVISON

Do you relate more as an entrepreneur or a working artist?

I definitely think of myself as a working artist, which is one of the biggest challenges for me. How do I translate my art into something reproducible that has market appeal? As a greeting card designer, I have to cater to popular holidays and avoid obscure images that may excite me but don't work on a card. I still execute my vision, but I do have to keep the consumer in mind.

How do you stay true to your brand?

Since our inception we've used fancy Italian cotton paper, hand-torn each card, hand-mixed each color, and hand-drawn each

design. I've had a hard time letting go of any part of this process because I love the tactility. That being said, I'm now working on figuring out what part of this job I can streamline without sacrificing my brand.

As your business expands, how do you decide which direction to grow in? Add more space or employees or products? What guides you?

As I grow, adding more designs and products is a must. Lines have to come out with more and more new products each year, especially for holidays. I have employees who do a lot of the screen printing, but they also help paint objects, pack orders, lay out work in Illustrator, and keep me sane and organized. As we grow, I'd like to delegate more of the day-to-day work, and focus on new design work, custom projects, and growing the overall brand. But I do struggle with letting go of the details!

What do you find most inspiring about your studio?

My two-room space allows for a flexible environment. I usually have a tidy room for new projects and so I can clear my head. My messier printing room lets me throw caution to the wind. I can get ink on the floor or on tables, and I can spread out over my big worktables. Having good light also makes all the difference. I love my windows.

How have you grown as a businessperson?

Every year it gets a little easier. I've learned how to stay organized, by having lots of lists—"to print" lists, daily task lists, monthly tasks, etc. I also color code folders on my desktop and email. It helps to keep everything from looking like a blur. I've also become comfortable saying no to projects that don't make good business sense. That's hard when you first start out. You want to say yes to everything because it's work, but it may end up taking up all of your valuable time without creative or financial growth in return. Learning to say no is important! Even more important is staying organized.

A DAY IN THE LIFE

I wake up at 8:00 a.m., and eat breakfast
and drink coffee. Then I answer emails. I
write up invoices that I have to start and put
them in piles. I tear some paper for the day's
printing. I get my staff ready by pulling their
inks. Then I typically spend another few hours
on the computer corresponding on email.
Later in the day, I might work on new designs
or custom projects. I always try and make my
lunch so I can eat it outside in the sun before
getting back to work. I end my day packing
orders and prepping for the next day. It's not
wildly glamorous, but it's rewarding!

FRINGE GREETING CARD

Whether you are throwing a party and want to make the invites or just want to send a festive note, this card is sure to brighten up the mailbox. The sample image uses twelve different colors, but you can use as few as five.

SUPPLIES
- Colored origami paper (can be any colored paper but thinner is better)
- Blank cards
- X-ACTO knife
- Ruler
- Glue stick

DIRECTIONS
1. Stack all your sheets of paper together and cut horizontal strips that are 1½ in/4 cm by the width of your folded card.

2. With the X-ACTO knife, cut thin vertical fringe approximately halfway down the length of the strips, using your ruler to be precise.

(continued)

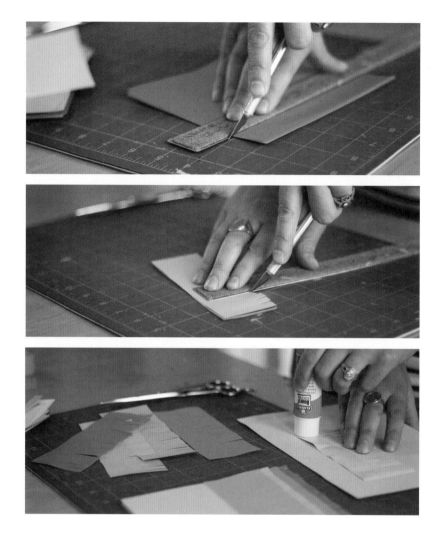

3. Separate the long horizontal strips that you just cut and use your glue stick to affix one strip to the bottom of the card, making sure to leave your freshly cut fringe unglued.

4. Glue the remaining strips on top of one another, allowing for approximately ¼ to ½ in/6 to 12 mm between each color, depending on how many colors you've chosen (allow for more space between colors if you have fewer color strips and less space if you have lots of colors).

5. Be neat and tidy by trimming excess fringe from the edges of the card.

MAKE ME A MIXTAPE: INSPIRING SONGS FROM THE STUDIO

1. Tommy James and the Shondells, "Crimson & Clover"
2. Kendrick Lamar, "Backseat Freestyle"
3. Neil Young (really anything by Neil Young), "After the Gold Rush"
4. Active Child, "Hanging On"
5. James Blake, "Retrograde"
6. Chromatics, "In the City"
7. Fleetwood Mac, "Never Going Back Again"
8. Grimes, "Genesis"
9. Robyn, "Dancing on My Own"
10. How to Dress Well, "& It Was U"

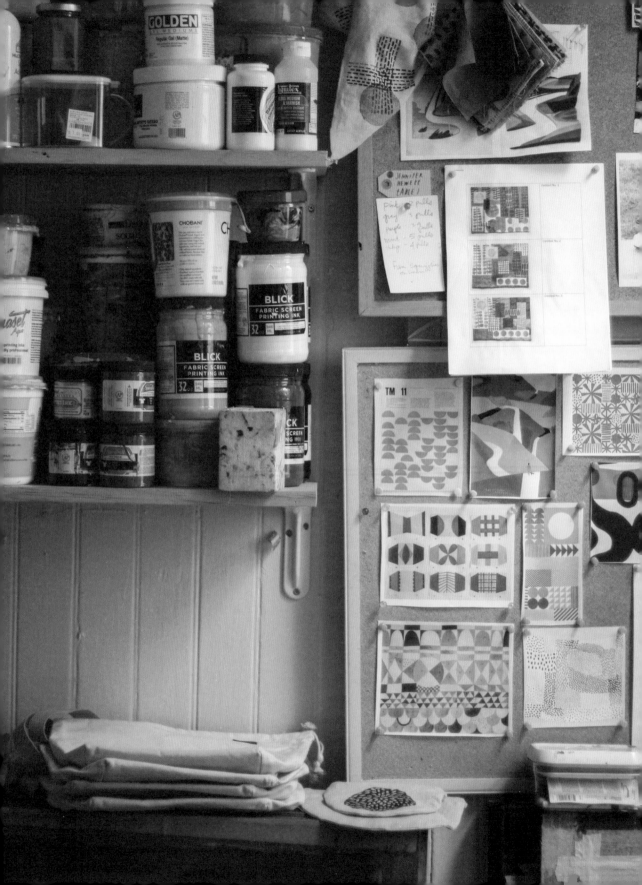

JEN HEWETT

SAN FRANCISCO, CALIFORNIA

JEN HEWETT
PRINTMAKER

Finding your calling as a working creative doesn't have to happen right out of college; sometimes it takes years. Such was the case for California-based printmaker Jen Hewett. After graduating from U.C. Berkeley, Jen worked as an AmeriCorps program coordinator, and then a high school admissions officer. In her mid-twenties, she decided to try working for herself by starting her own stationery line, which was not as successful as she would have liked. She closed down that business and licensed her work. That led her to a completely different field, doing HR consulting for startup tech companies, while still doing a bit of printmaking on the side. This consulting work afforded her the time she needed to find her voice. In 2015, Jen began to work as a full-time printmaker. She also makes time to teach printmaking classes both online and in person, something else Jen is passionate about.

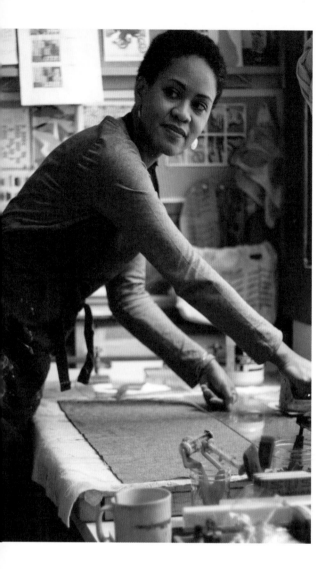

A CONVERSATION WITH JEN HEWETT

Did you read business books, learn from hands-on experience, or get another form of business advice?

I tend not to go to outside resources much for business advice. I have a very strong sense of what I want my business to be—and not to be—and I've found that advisors want to push me to grow my business to be much bigger than I want. But that may be because I live in the Bay Area, where startup culture dominates everything. I'm so fortunate that I have a community of friends who are successful working artists. Being surrounded by this community, I've seen that there are so many different ways to manage an art career, that there are different paths and different ways to define success. I also meet monthly with three other working artists to discuss our businesses and work through problems.

How have you grown as a businessperson?

One of the most important takeaways from consulting is that my time has value. Not just an abstract value, but also a monetary value. When I make decisions about which projects I want to take on, I think about what will bring me joy, what will help grow my career, what will bring me the most income. It's easier to make decisions when I focus on those things.

"I have a fairly strong sense of who I want to be as an artist, and I make decisions that support that." —Jen

What do you find most inspiring about your space?

My space is tiny. It was never meant to be a studio, and I am constantly moving things around in here so I can draw, paint, print, and sew. My tiny studio forces me to be super disciplined and resourceful.

As your business expands, how do you decide which direction to grow in? Add more space or employees or products? What guides you?

After running my stationery business, and then working with other entrepreneurs, I realized that I do not want to manage a team, or take on large amounts of debt, or manage a large production process. This means that I don't do much wholesale, and that my collections are small and focused, rather than broad. At some point, I would like to bring on an assistant to handle the administrative side of my work, and possibly someone with more developed design skills to do some layout work for me. I do hope to shift more into licensing in the next couple of years, leaving me more time to create limited-edition printed textile work, as well as to focus on my fine art practice.

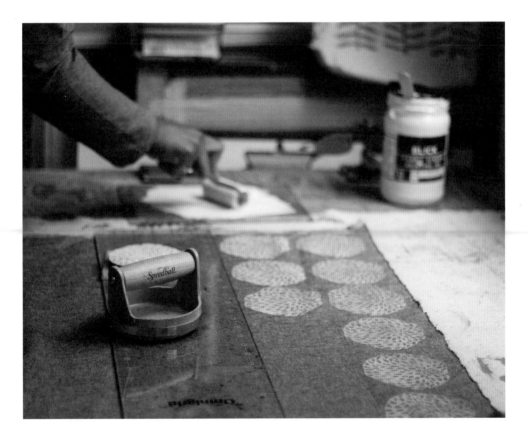

A DAY IN THE LIFE

I am a creature of habit! I wake up at
6:30 a.m., and spend half an hour or so
writing. I did Julia Cameron's *The Artist's Way*
many years ago, and I still do my morning
pages every weekday. After that, I walk my
dog. Breakfast, then I'll check email, queue up
social media posts for the day, and be ready
to start working in my studio by 9:00 a.m.
Mornings are usually about doing creative
work—drawing, carving, printing. After a
quick lunch break, I check my email again,
then wrap up my creative work if I have any
admin work I need to do that day. After walk-
ing Gus again, I work until about 6:00 p.m.,
when I head to the gym for an hour. After
working out, it's time for dinner or a trip to the
neighborhood wine bar. I'll usually spend the
rest of my evening reading, watching an hour
of junk TV or shows online, or tidying up. I'm
in bed by 10:30 p.m. every weeknight.

ZIPPERED PENCIL BAG

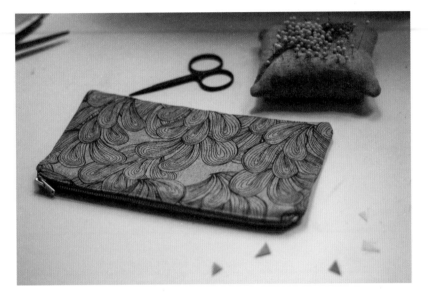

This little pouch is the perfect size for carrying pens and pencils, or to tuck inside your carry-on bag when traveling, for all the little things you might need to stash.

SUPPLIES

- Two 10-by-6-in/25-by-15-cm pieces of fabric for the exterior of the bag
- Iron
- Straight pins
- 9-in/23-cm zipper
- Sewing machine with zipper foot
- Coordinating thread
- Two 10-by-6-in/25-by-15-cm pieces of fabric for the interior the bag

DIRECTIONS

1. Fold the top edges of both pieces of your exterior fabric down by ⅜ in/1 cm. Iron.

2. Pin the top edges of the exterior fabric to each side of your zipper tape. The top edge of your fabric should be as close to the zipper teeth as possible, without actually touching the zipper teeth. Repeat on the other side.

(continued)

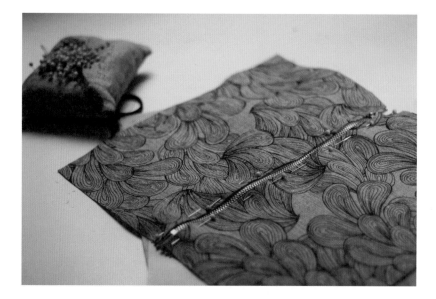

3. Using your machine's zipper foot and coordinating thread, sew the exterior fabric to the zipper, as close to the zipper teeth as possible.

4. Next, align the edge of your lining fabric with the edge of the underside of your zipper tape. Pin in place.

5. Using your zipper foot, sew the interior fabric to the zipper, as close to the zipper teeth as possible.

6. Unzip the zipper halfway.

7. Align the right sides of your bag together and pin along the remaining three edges, catching both the fabric and the lining in the pins and making sure both fabrics are smooth.

8. Sew together, using a ½-in/12-mm seam allowance. Leave a 3-in/7.5-cm gap at the bottom of the long edge so you can turn it right-side out.

9. Turn your bag right side out.

10. Sew the bottom of the lining closed. Push the lining into your bag.

11. Zip closed and give your bag a nice pressing. You now have a zippered bag!

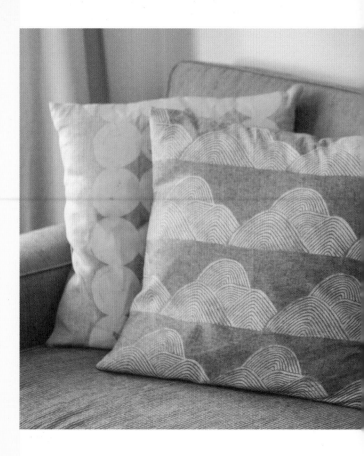

MAKE ME A MIXTAPE: INSPIRING SONGS FROM THE STUDIO

1. Nina Simone, "My Baby Just Cares for Me"
2. Stevie Wonder, "Don't You Worry 'Bout a Thing"
3. Lou Rawls, "You'll Never Find Another Love Like Mine"
4. The Smiths, "What Difference Does It Make?"
5. Missy Elliott, "WTF (Where They From)"
6. Blackstreet, "No Diggity"
7. Curtis Mayfield, "You're So Good to Me"
8. Marvin Gaye, "After the Dance"
9. Marvin Gaye, "Come Live with Me Angel"
10. Curtis Mayfield, "Move on Up"

JENNY PENNYWOOD

SAN FRANCISCO, CALIFORNIA

JEN GARRIDO
PAINTER

Born and raised in Los Angeles, Jen Garrido went to Sonoma State University where she received her BFA in painting and then went to Mills College in Oakland, California, for her MFA in studio arts. After graduate school, Jen was a K–8 arts teacher and waited tables. She was also an Affiliate Artist at the Headlands Center for the Arts before going to work for herself in 2008. When the economy started going under, all of the galleries that represented her work closed. That led her to create her Jenny Pennywood line so she could promote her own work. Jen has collaborated with Lena Corwin to form a third business, a children's and women's clothing line, See Sun, combining their art and textile work for the clothing patterns. She still paints, mostly floral watercolor paintings, under her name Jen Garrido.

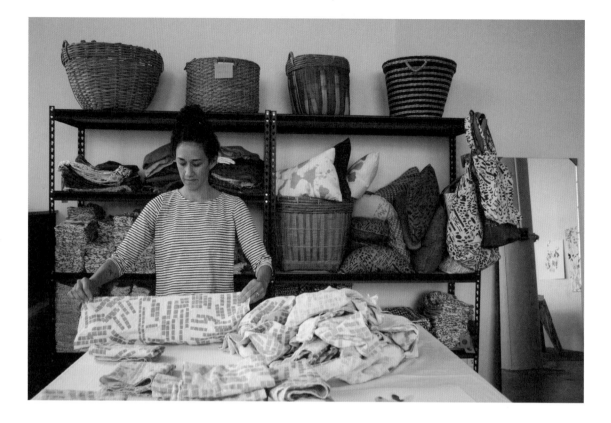

"First and foremost, my desire to create is what keeps me going. It feels good . . . well, most of the time it feels good. I also love feeling successful both personally and professionally. So I guess what also keeps me going is a drive to feel successful." —Jen

A CONVERSATION WITH JEN GARRIDO

How did you launch your business?

About ten years ago I decided to leave teaching and do my art full time. At the time I was working with several galleries and I was making some money. In 2008, when the economy dumped, all my galleries closed and I was left with having to start something new. At the same time my now husband and I got engaged. My dad had put aside some money for my wedding, so what I did was produce my wedding under the name Jenny Pennywood. *Martha Stewart Weddings* magazine featured it, and that is how Jenny Pennywood began to take shape.

Do you relate more as an entrepreneur or a working artist?

More as a working artist posing as an entrepreneur; also a working artist faking as an entrepreneur.

How did you stay focused and original when you were starting out?

I have always kept working on my artwork. I can't remember a time when I wasn't focused on that. But in the beginning I spent a lot of energy thinking that I was supposed to be going somewhere specific with my work and judging myself for not going in that direction. I had many opportunities that I said no to because, at the time, I thought there was something better. And when I look back at the things I was saying no to, now I feel like "Why didn't I say YES! They were good opportunities."

Around the time the economy crashed in 2008 and the galleries that I was working with closed and things began to shift with my fine art, I created Jenny Pennywood. And Jenny Pennywood didn't have a direction—she was just the name that I created so I could basically make whatever I wanted and it didn't have to touch my fine art career. I spent the next few years working through directions, making NO money, and figured out a few things. I got married, had a kid, and all of those things helped to just "ride the wave" or just go with whatever was coming my way. I started saying YES to things and not judging myself for it.

I now see that whatever comes my way is supposed to be in my life or I am supposed to experience it in some way. Before it was like I was pushing in the wrong direction and I seemed to always feel out of place or dissatisfied . . . I don't feel that way anymore.

As your business expands, how do you decide which direction to grow in?

It is an organic process, and paying attention to what is coming up for me guides me. That said, I feel like in order to "think bigger" I need to be less organic and more strategic, but I'm still trying to figure out how to do that. It isn't in my nature to be that way.

A DAY IN THE LIFE

Starting early, going into the night. Wake up, make lunch for my daughter, take a shower, take Jemma to school. Go to my studio, sit down, email for a long time, make phone calls, and toward the end of the day turn on music and paint until I have to leave at 4:30. Pick up Jemma, go home, make dinner, put her to bed, and do more emailing and watch TV.

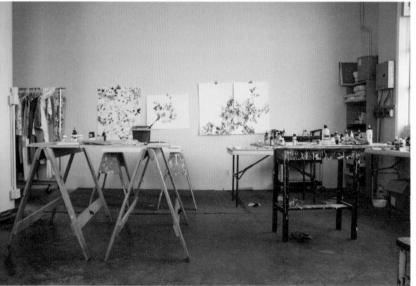

HAND-PAINTED CARDS

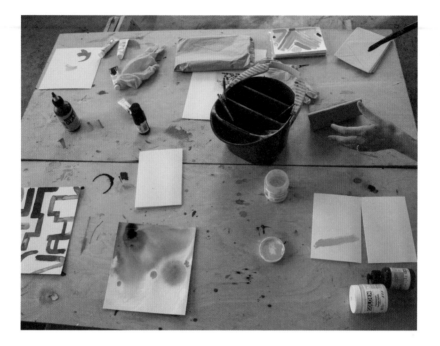

Just like when you were a kid, when you'd make a card for your grandparents, now you can send a more refined, grown-up version to all your friends.

SUPPLIES
- Card stock
- Paint
- Paintbrush

DIRECTIONS
1. Just pull out all the materials and go for it. There are no rules to making these cards.

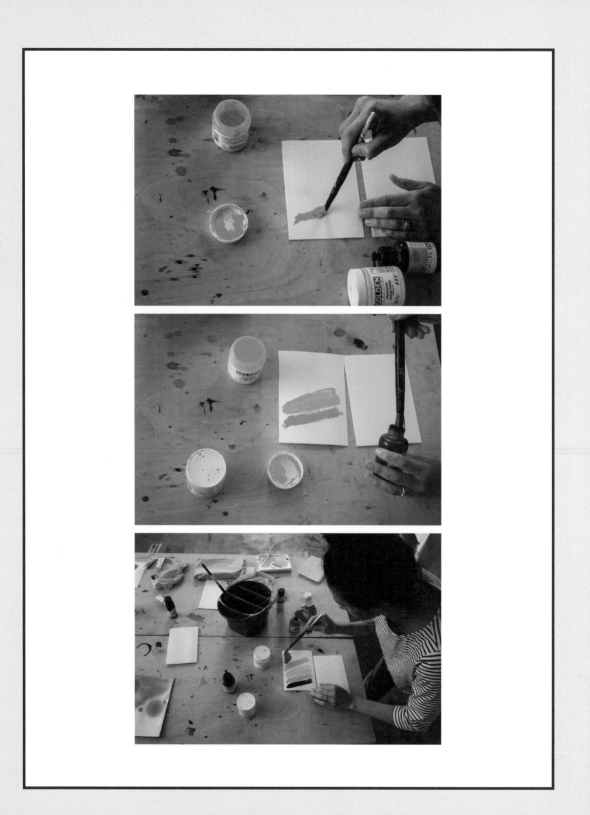

MAKE ME A MIXTAPE: INSPIRING SONGS FROM THE STUDIO

"I listen to these albums over and over again when I'm working in my studio. I can't narrow down the songs." —Jen

1. Bahamas, *Bahamas Is Afie*
2. Bahamas, *Barchords*
3. The Staves, *Dead & Born & Grown*
4. Lowercase Noises, *Vivian*
5. Arcade Fire, "Song on the Beach"
6. The Range of Light Wilderness, *The Range of Light Wilderness*
7. Beirut, *The Rip Tide*
8. One Direction . . . I just listen to whatever because they are so poppy good!
9. Ryan Adams, *Heartbreaker*
10. Ben Kweller, "I Need You Back"

KATE ROEBUCK STUDIO

CHATTANOOGA, TENNESSEE

KATE ROEBUCK
PAINTER

Kate Roebuck is a painter, textile designer, and all-around inspired maker (pillows, jewelry, hand-painted totes, and more). She grew up in Pittsburgh, Pennsylvania, and a strong desire to see and know other parts of the country led her to Athens, Georgia, to attend the University of Georgia Lamar Dodd School of Art. Before starting her company, Kate Roebuck Studio, she worked as a full-time designer for Hable Construction, traveling back and forth from her home in Mississippi to Athens, Georgia, to have an immersive workweek and then back home for three weeks of independent work. She now lives in Chattanooga, Tennessee, and often travels to Georgia and Mississippi for work.

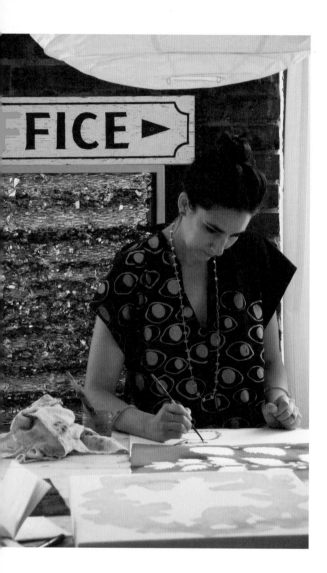

A CONVERSATION WITH KATE ROEBUCK

What have been the biggest hurdles to growing your business?

There are always going to be hurdles. Many of them. My thought is that the biggest hurdle for artists is themselves. Self-doubt, frustration, jealousy, distraction . . . the uplifting list goes on! Working on yourself helps eliminate those hurdles, so that you are your best supporter and sharpest tool. I always ask myself, "If you're not on your side, then who is?"

What have been your biggest rewards of being a self-employed working creative?

There are so many rewards to working for yourself, but it is easy to let those rewards slip by. It helps to have other artists working around you, cheering you on. Two things I have learned about working independently are this: It's easy to never stop to smell the roses. STOP. AND. SMELL. THE. ROSES. (They are sweet!) I like to have little success check-ins each week, by running down my written list, giving myself the satisfaction of checking items off. Did I do what I said I was going to do? Did I reach any of my goals this week? Did I have a really great time in my studio? They don't have to be monumental, but reward yourself for small successes, too; positivity is everything.

As your business expands, how do you decide which direction to grow in? Add more space or employees or products? What guides you?

"As an artist, the community I seek to support is one that gives freely and shares in each other's success." —Kate

I love this question. When Bowerbird Collective first started, it was "Shop Bowerbird." My sister-in-law and I were law school wives in the same town and wanted something to work on together for some extra income while our husbands (who are brothers) went through the depths of law school. We began buying vintage and antiques, staging elaborate installations with these items and then photographing them and selling them on Etsy.

Fast-forward five years and we now sell and exhibit our work together under Bowerbird Collective and work independently on our own businesses as well, Laura's being a mother of two boys (which, for the record, is WAY harder) and mine being Kate Roebuck Studio. The reason this question is important is because I love telling people that this was all a natural progression. Because our audience was willing to grow and change with us, we were able to grow and change, which is a reflection of real life. Our commitment in business was to love each other first and what we do second. Through this we have been able to continue working together, and also working on our own endeavors—the latter becoming our business priorities. My guiding principle for growth is that it needs to grow organically for it to last. Do not rush, be patient.

How do you see your brand growing in the next five years?

Someone once told me to grow your business from where you are outward. Starting in your own home, then your surrounding community, then maybe within your state, and onward. I hope to grow this way, making relationships along the way, enjoying each day. I hope within the next five years to have more gallery representation, and also to be navigating the uncharted waters of being a mother and an artist.

A DAY IN THE LIFE

The second I wake up (around 6:00 a.m.), I make my bed, then coffee. There is something special to me to start this way; it's like greeting the day, saying, "Hey! I am so ready for you. Bring it." Next I try to have a little quiet time, and then it's off to the races! I usually grab a quick breakfast to go, and then I get down to my studio. Morning in my building is pretty tranquil and I enjoy arriving early to steal a piece of that calm. I usually check some emails and do some business-related tasks, and then I get painting. Knowing that I am most productive in the morning, I try to do the hardest tasks early. The afternoon is when I lose a little steam, so this is when I will take a break for lunch or a walk; my suitemate and I will try to exercise during this time at the park across the street or go to yoga. I try to put in nine- or ten-hour days in my studio, though in the spring I also coach lacrosse at a local high school, so my time is shorter because I have practice or games in the evenings. After I end my workday, I usually go home, make some dinner for my husband and me, and try to reserve the evening, undistracted by work or phone, for family. We usually watch something on Netflix or read, and then I go to bed around 10:00 because I have worn myself out.

HOMEMADE
WATERCOLOR PAINT

When you have that idea in your mind for a color and you just can't find it anywhere, or when you truly want to create your very own palette, try this project.

SUPPLIES

For the Vehicle:
- Mason jar
- 1 tablespoon gum arabic
- 1 teaspoon glycerine
- 1 teaspoon honey
- 1 drop clove oil
- Spoon or palette knife

For the Watercolor:
- Respirator and gloves
- 1 teaspoon vehicle (previous)
- Glass/acrylic palette
- Palette knife
- 1½ tablespoons pigment
- Mason jar
- Cheesecloth and rubber band, if needed for drying

(continued)

DIRECTIONS

1. Start by mixing your vehicle: In a small mason jar, combine the gum arabic, glycerine, honey, and clove oil with a spoon or a palette knife. This will make more than you need for one batch, so you can store the excess covered in the refrigerator.

2. To make the watercolor, put on the respirator and gloves. Pour the measured vehicle into a little hole on the palette.

3. Using your palette knife, start mixing the pigment with the vehicle. The pigment will start to become "wet" and paintlike—this can take up to an hour to become really smooth. If you find the pigment won't break down and pills when you're trying to mix with the vehicle you can add tiny amounts of water to help it mix, only adding as needed.

4. When it is done, place it in a glass jar. If it is very wet you will need to let the moisture evaporate a bit overnight by leaving it out with a piece of cheesecloth over the top of the jar, secured with a rubber band.

MAKE ME A MIXTAPE: INSPIRING SONGS FROM THE STUDIO

1. Hope for Agoldensummer, "Malt Liquor"
2. Jack White, "Love Interruption"
3. The National, "Terrible Love"
4. Reptar, "Houseboat Babies"
5. Kishi Bashi, "Bright Whites"
6. Reptar, "Sebastian"
7. The National, "Sea of Love"
8. Laura Marling, "I Was an Eagle"
9. Reptar, "Isoprene Bath"
10. Laura Marling, "Devil's Spoke"

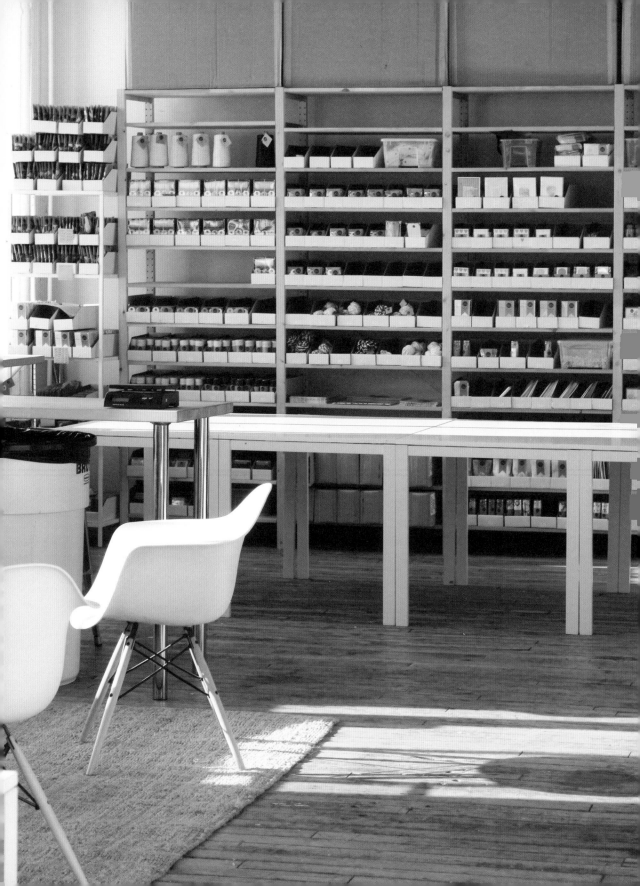

13
———————

KNOT & BOW

BROOKLYN, NEW YORK

———————

ERIN OZER
PARTY GOODS DESIGNER

With several degrees, including a BFA in design, a BFA in art history/museum studies, and a master's degree in art administration, Erin Ozer has taken an educated route to get Knot & Bow where it is today. What started as a need to contribute to her family finances while juggling new motherhood, Knot & Bow, a party goods company, can now be found in more than a thousand stores around the world.

A CONVERSATION WITH ERIN OZER

How have you grown as a businessperson?

Although I'm not always completely sure of myself, I believe I'm a truly knowledgeable businessperson now. I certainly don't know everything, but I realize more and more that I've grown to be quite competent in business and my drive to keep growing has made me secure in that. When I first started out I was really in over my head, and making things up more often than not. I trust my instinct and my gut more easily, because I have so much more experience to base it off of. I spend less time doing and more time delegating and managing. I'm learning how to step back and look at the bigger picture more and more.

Do you relate more as an entrepreneur or a working artist?

More as an entrepreneur. I have more confidence in my art and design skills than I used to (I used to be afraid of calling myself a "designer" for reasons of low self-confidence, but now I realize I am one!), but my skill set is so much more than that. I spend more of my time running and growing my business than I do designing products. And even when working on new products, I analyze our sales, product popularity, etc., before moving forward with anything new. We have a lot of retail stores and have to appeal to the mass market, so this kind of information becomes an important component in our product design.

"The whole experience of running a business feels a lot like jumping into the deep end of a pool without a float. But I'm the kind of person who just figures it out!" —Erin

In the world of Etsy and Pinterest, how do you stay ahead of the game and original while still staying in line with your brand?

We don't look around at the market when we are developing new products. We try to look within, at our own product line. What would be a complement to what we already have? What are we missing? What have our customers been asking for? I try to look at overall trends, and we actually get a few fashion magazines in the studio to help with this. Before we launch a new product, we check to see what is out there, to make sure we are not too close to anything that is already on the market, and to ensure originality. If we see that someone else is already doing it, we'll skip that product.

How do you go about sourcing materials for your goods?

We outsource our products in bulk. For example, when we design confetti, we choose all of the colors, shapes, and combination of materials that we want in that blend. Then we place an order for a large quantity of that particular color combination and divide that up into smaller packages in our studio and finish it all by hand. When we work with an outside manufacturer to produce a product for us, it's a long road to building that relationship. We do research to find someone who makes what we are looking for, have phone calls about production processes, request samples, and discuss pricing. We often revisit the samples several times to revise until the product is the way that we want it. The great part about this is that we have really wonderful

relationships with our manufacturers and are in contact with them on a regular basis. It's like an extension of our little company. Some of our manufacturers have been able to invest in special equipment or expand their staff because of the orders that we send to them, which is quite amazing.

A DAY IN THE LIFE

I wake up around 7:00 a.m. We get ready for the day and we walk our kids to school—we're lucky to be able to walk together as a family most days. Then Chris, my husband, and I head to the studio and usually make our second cup of coffee there. I like to go through my emails first thing and get my to-do list in order. Then I divide my time based on top priorities. At different times throughout the year I'm working on new product development, catalogs, social media, photo shoots, hiring and employee management, web stuff, and more. I usually have meetings with our accounts team or studio manager sprinkled throughout the day, and probably a phone call with my lawyer or accountant. I love cooking, and making dinner has become one of my favorite parts of the day. Once the kids are in bed, I usually take out my laptop and get back to work again for a little bit. But some nights I just take it easy and relax with my husband with a good documentary or (if I'm feeling particularly tired) some excellent reality television. I usually stay up way too late and regret it later.

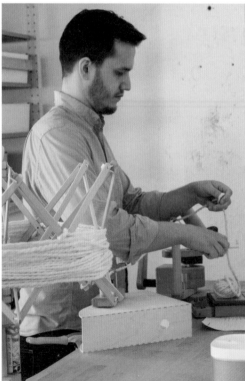

SEQUIN NECKLACE

When you just can't find that perfect necklace for your new outfit, make one! Pick the length and color you'd like, as this will be your new go-to accessory.

SUPPLIES

- Sequins, color of your choice and amount of your choice
- Tiny brass beads, amount of your choice
- Silk thread

DIRECTIONS

1. Simply thread the sequins and beads onto the silk in the pattern of your choice.

2. Tie with a tight knot.

3. Enjoy! For an extra bonus, glue a few sequin clusters onto a kraft box to gift the necklace to someone.

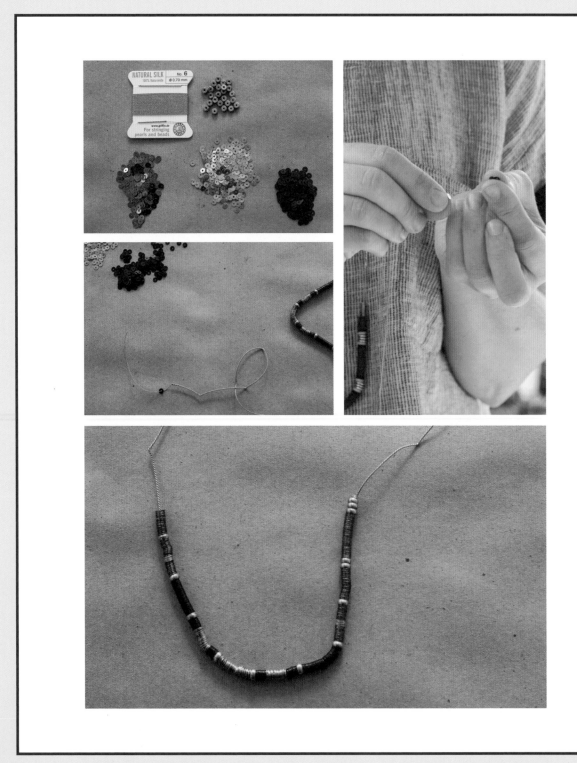

MAKE ME A MIXTAPE: INSPIRING SONGS FROM THE STUDIO

1. Cocorosie, "Werewolf"
2. Girlpool, "Before the World Was Big"
3. Wild Nothing, "Chinatown"
4. Phosphorescent, "Wolves"
5. Youth Lagoon, "Highway Patrol Stun Gun"
6. Sam Amidon, "Lucky Cloud"
7. Cat Power, "Manhattan"
8. Wye Oak, "Two Small Deaths"
9. José González, "Stay Alive"
10. Courtney Barnett, "Depreston"

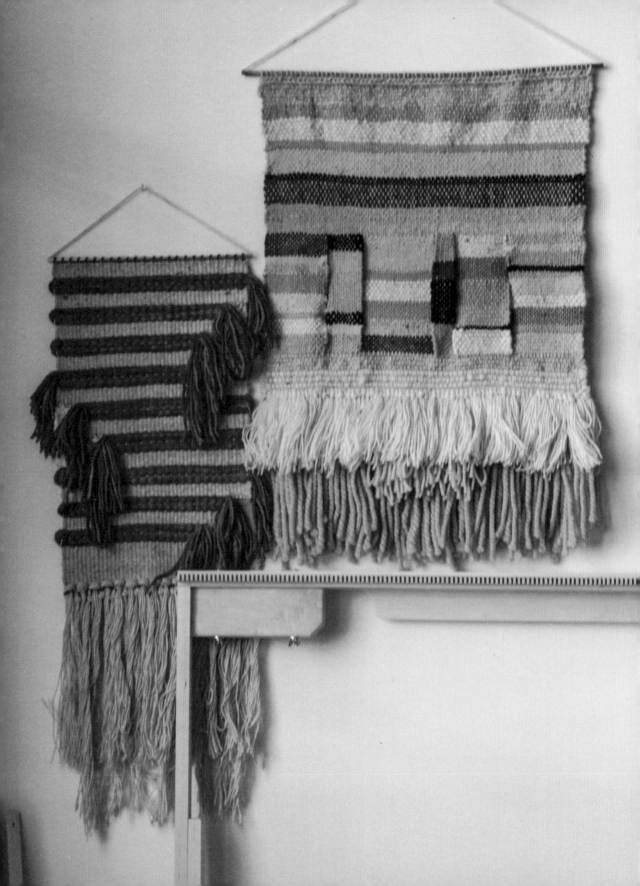

MARYANNE MOODIE

BROOKLYN, NEW YORK

MARYANNE MOODIE
WEAVER

Originally from Australia, Maryanne Moodie now lives in Brooklyn, New York. She has always been creatively driven in her professional life. Her various roles have included teaching art and vintage merchandising, and she now hosts sold-out weaving workshops and grows a successful online business of her own work.

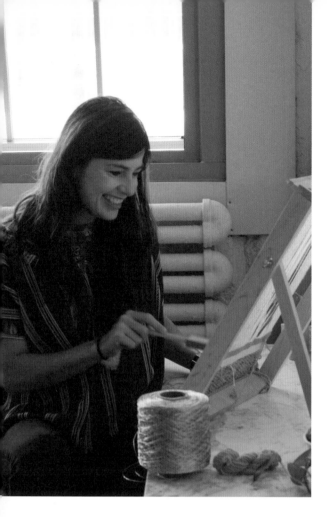

"In this day and age, you really need to wear a lot of different hats to run and grow your business. And I try to keep my followers and customers at the forefront. I really listen to them; I think they are my experts."
—Maryanne

A CONVERSATION WITH MARYANNE MOODIE

How much of your business have you been able to keep hands on and how much have you had to source out? What's most important to you when sourcing?

We do everything, really. We have a woodworker who makes our looms and tools, but other than that—it's all us! We source vintage yarn online and we also buy a lot of hand-spun and hand-dyed yarn on Etsy from small women-run businesses. Sustainable products and supporting small businesses is most important to us when sourcing.

As your business expands, how do you decide which direction to grow in? Add more space or employees or products? What guides you?

Listening to my followers is always a good start. They are the ones with the ideas that show me where growth is possible. Then we evaluate the possibilities of sourcing sustainable materials and time management. We want to offer what we can in a way that is soft on the earth and does not have our team pulling its hair out.

How do you remain original while still staying in line with your brand?

I weave every day and I never make exact replicas of my work. Every piece is different. Every time I weave, I try something new. It keeps me challenged and interested.

How do you and your team stay organized?

We have lots of systems, such as speed sheets, different apps, and lots of written lists, in place as a studio to keep on top of incoming orders and what has gone out. We also have inventory documents and an online calendar that we all share. It means that we are all aware of what is happening and what needs to be done.

How have you grown as a businessperson?

I now know a lot more about keeping financial documents, taxes, government forms, and the legal side of running a business. I have also learned to hire people to do the tasks that you don't like or are not an expert at. That way you can focus less on the "business" and more on what you are good at.

A DAY IN THE LIFE

I start by waking up with my two-year-old
son, Murray, and my husband, Aaron. Grind
the beans and make good coffee. We all
eat breakfast together, talk about what we
dreamed about. Then it's all systems go to get
them out of the house before my lovely ladies
arrive for the morning of work. We are still
at my home, and so I try to make the house
look neat and feel inviting for them. When
they arrive, we survey the tasks for the day/
week and get moving. I usually weave while
they take care of administrative tasks. My son
comes home halfway through the day and I
stop and eat lunch with him, talk about his
morning, read some books, and put him down
for a nap. Then I finish off the Studio MM
tasks for the day while he naps. If the weather
is fine in the afternoon, I try to do something
outdoors with my son. Otherwise, we do
yoga or art or go to a friend's house. Murray
goes to bed at 7:00 p.m, so I usually do a few
emails and administrative tasks before Aaron
gets home from working at Etsy. We cook
and eat dinner together and try not to do
any work in the evenings and concentrate on
having some quality time together.

WOVEN COASTER

Learn the basics of weaving with this fun project. You will get a feel for the art while making useful coasters, pot holders, and more. You can apply these directions to make larger weavings if you'd like.

SUPPLIES
- Scissors
- Cardboard
- Ruler
- Pencil
- Strong cotton thread
- Yarn of your choice
- Needle (optional)
- Fork

DIRECTIONS
1. Cut your cardboard to slightly larger than you'll want your coaster.

2. With a ruler and pencil, measure and mark ⅜-in/1-cm intervals across the top and bottom of the cardboard.

3. Cut approximately ⅜-in/1-cm in from each mark to make a slit. Once

(continued)

you've cut in all your marks, you've made your loom.

4. Warp your loom with the strong cotton thread (these are the threads you will weave your yarn under and over). Insert the thread down into the first slit at the top. Keeping the thread taut the whole time, insert the thread into the corresponding bottom slit, move over to the next bottom slit and come up through that slit, and then bring the thread up to the top slit. Continue until you have moved across the cardboard to all of the slits.

5. Begin to weave with your yarn, starting at the bottom and going under one warp and then over the next (a needle makes this easier). When you reach the end of a row, turn back around and continue weaving, doing the opposite of what you did the row before. Be careful not to pull the sides in too tight as you work. Use a fork to snug each layer down to the one below.

6. Weave all the way to the top of your loom, creating whatever pattern you'd like.

7. Cut the warp ends and remove the weaving from the loom. Tie the warp ends together in sets of two with double knots. Once they're tied off you can either leave them hanging or weave the threads into the back side of your coaster.

8. Double knot the yarn ends and tuck them into the backside of the weaving. And you're finished.

MAKE ME A MIXTAPE: INSPIRING SONGS FROM THE STUDIO

1. Fleetwood Mac, "Landslide"
2. Blondie, "Union City Blue"
3. The xx, "VCR"
4. Stevie Wonder, "Master Blaster"
5. Jenny Lewis, "Head Underwater"
6. Arthur Russell, "Make 1, 2"
7. LCD Soundsystem, "Set the Controls for the Heart of the Sun"
8. Leonard Cohen, "So Long Marianne"
9. Mariachi
10. Vintage '60s pop

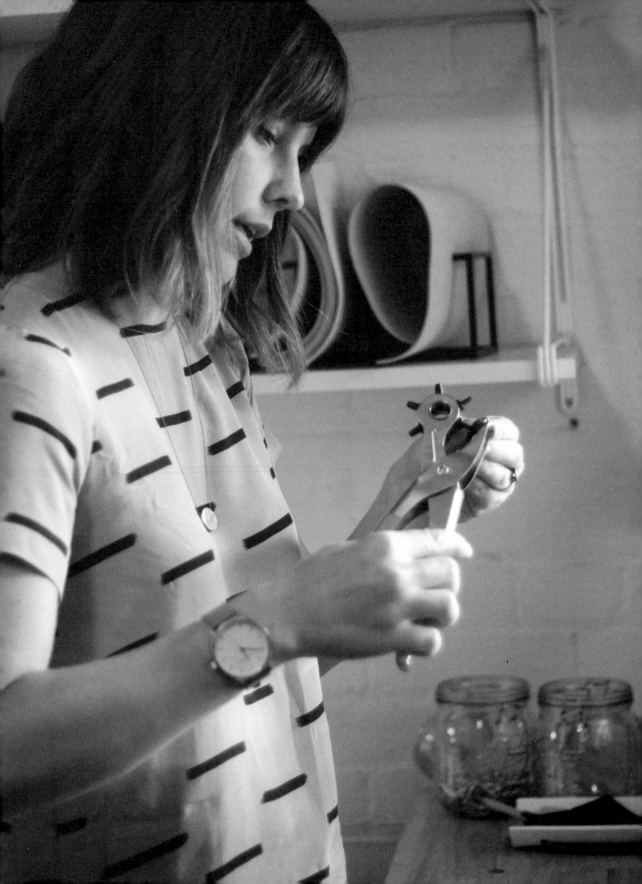

15

———

MATINE

WASHINGTON, D.C.

———

CAROLYN MISTEREK
LEATHER WORKER

When Carolyn Misterek started MATINE, she was working a day job and getting her master's in art history. Once school was over and she had a few years of experience working for someone else, she felt the need for more. She had grown up in an entrepreneurial family and, watching her dad work for himself, recognized it was a luxury—an attainable luxury—to get to determine your daily work/life balance. She quit her day job so she could design a schedule that suited her priorities on any given day—to grow a family, to be creative, and to be her own boss.

"It's hard to feel like an artist while you're answering emails." —Carolyn

A CONVERSATION WITH CAROLYN MISTEREK

What have been the biggest hurdles to growing your business?

For someone with a creative background, as opposed to a business background, the entire thing is a learning curve. The very biggest hurdles for me recently have been figuring out how to delegate and how to scale production. I've built this business on my own, so naturally I'm used to having all the control. At some point, though, you admit that you can't do everything yourself if you're going to grow. That's when you start to think about when and how to hire help, outsource to factories, streamline materials sourcing, expand physical studio space, etc. All of these issues are the natural side effects of positive growth, but it can be so hard and scary to figure it out on your own. I've learned a lot through trial and error.

How do you stay organized?

Lists, lists, lists! I have lists everywhere at all times. There are short-term to-dos, longer-term things I just don't want to forget about, and everything in between. I don't have anyone to oversee the workflow, so I continuously update lists as items move through different phases of production. When I'm feeling overwhelmed or have a really chaotic week, I sit down to list out every single thing that needs to be done, and when it's due. Then I backtrack from the due date into the tasks that need to be

completed each day until then. Getting a view of the big picture and seeing exactly which days might be heavier or lighter is so calming and helps me feel like I am in control and mentally prepared when things get chaotic.

How do you stay true to your brand?

Because I run this business entirely on my own, it's all on me to maintain the brand, so I need to be able to have straightforward conversations with myself about whether or not something fits. There have been many, many pieces that I've designed, made, and loved, but ultimately had to cut out of a collection because they just didn't feel like MATINE. This kind of honesty with yourself is also really important when learning how and when to say "no." Collaborations and partnerships are the types of things that can be great for your business, but you have to be diligent about protecting your brand when the fit isn't there, aesthetically or otherwise. It can be tempting to say yes to any and all exposure, but you have to be protective and careful because no one else is looking out for your brand but you. Staying true to the brand comes into play on every single choice you make every single day, not just in product design. From the language you use in an email to your Instagram photos to packaging and customer service, everything you do is reflecting your brand, so you need to work to make sure it's in a positive way.

A DAY IN THE LIFE

Our dog, Lou, is usually the first one up, anywhere between 6:00 and 7:00 a.m., and he patiently waits for my husband to take him out for a walk. I usually wake up and get the coffee going. When I worked my day job, I used to get up really, really early and spend hours in the studio before the workday even started. Now I like to ease into my day. I have coffee and watch morning news while catching up on emails and doing whatever work I can manage from my computer. That could be anything from updating the website to looking at analytics, invoicing, editing photos, or ordering supplies. Anything that can be done from the computer I like to do first, so I can stay in my pajamas and still feel productive. I head into the studio around 10:00 a.m. A few days a week I have part-time staff in the studio (which has been an amazing improvement in my daily life in the past year!).

Every day really is different in small business life. All of our products are made to order, so depending on where we are in the production process for any given order, the day looks a little different. We may spend a whole day just cutting pattern pieces and preparing for sewing. The next day we may spend the whole time sewing and finishing. Or we may get through several steps in one go and end the day packaging for shipment. In the evenings I pause and get dinner ready. I love to cook, and find preparing meals to be the ultimate decompressor after a long day. By the time my husband gets home around 7:00 or so, we can eat dinner right away and catch up on our days. Then we usually just chill together and watch some TV or I head out to a yoga class. If I still have work to finish or emails to write after dinner, I'll get back to it, usually from the living room so I feel like I'm spending some sort of quality time with my husband. If we're on a tight deadline, I'll pull an occasional all-nighter, but for the most part I love to go to bed early and try to get eight to nine hours of sleep.

COPPER LEAF NOTEBOOKS

Use copper leaf and a glue pen to dress up some notebooks—but you could apply it to notecards, envelopes, wrapping paper . . . the options are endless!

SUPPLIES
- Glue pen
- Paper-covered notebook
- Metal leaf (gold, silver, or copper would work)
- Brush

DIRECTIONS
1. Simply use the glue pen to draw out a design on the notebook cover—it could be a pattern, text, an actual drawing, anything!

2. Put down the leaf before the glue dries. Pat it on the glued areas gently and then brush off the excess

(continued)

leaf (I use an old eye shadow brush). I like to do this step over a Tupperware container so I can save and reuse the extra leaf.

MAKE ME A MIXTAPE: INSPIRING SONGS FROM THE STUDIO

1. Bill Withers, "Lovely Day"
2. Jack White, "Alone in My Home"
3. Chet Faker, "1998"
4. Milky Chance, "Stolen Dance"
5. Frank Ocean, "Lost"
6. Fleetwood Mac, "Second Hand News"
7. Wild Cub, "Thunder Clatter"
8. Justin Timberlake, "Let the Groove Get In"
9. Daft Punk, "Lose Yourself to Dance"
10. MGMT, "Electric Feel"

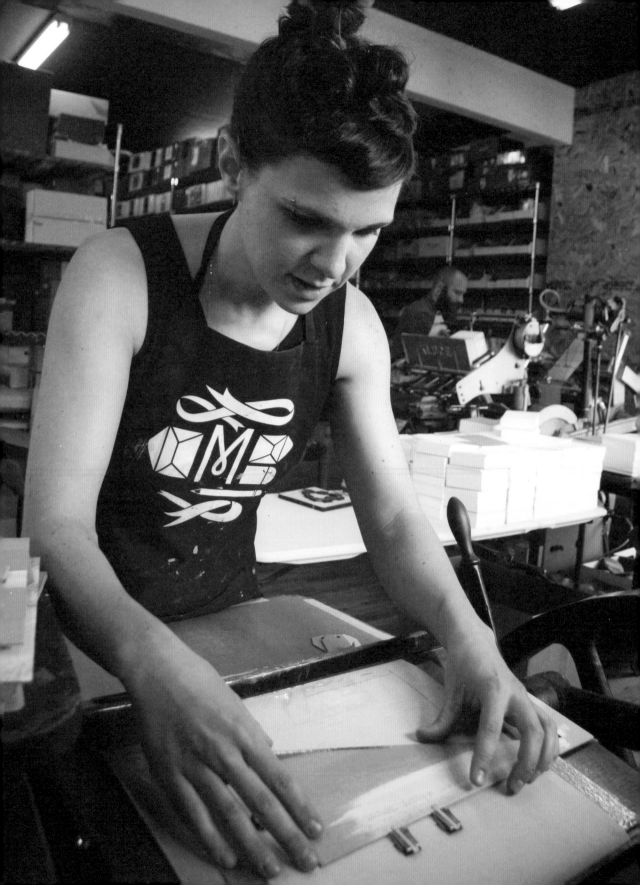

MOGLEA

AUDUBON, IOWA

MEG GLEASON
STATIONERY DESIGNER

Meg Gleason isn't your normal creative business owner. She did receive a degree in graphic design from Iowa State University, but other than that formal training, she is completely self-taught in her current field. After a one-week course in letterpress, Meg took the reins and built what is now a twelve-person company in the middle of a cornfield in Iowa. Her studio looks out on the family farm, and from her window she can see cows and pigs. This environment might seem isolated, but for Meg, it was just what she needed to focus on her art and create a business that was unlike anything else on the market. This mind-set is what has set her company apart; after just a few years, her work was selling in hundreds of shops.

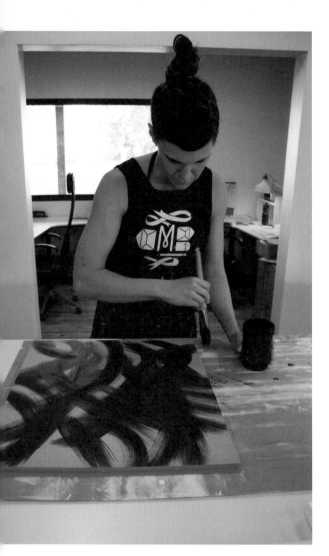

"I was terrified to launch anything until I felt completely confident in it. I didn't want to copy what was already out there." —Meg

A CONVERSATION WITH MEG GLEASON

As your business expands, how do you decide which direction to grow in? Add more space or employees or products? What guides you?

We've tried our best simply to stay ahead of the growth of our business. We started in our home with one part-time employee and at one time had five full-time employees working in our basement and kitchen. We've just had to adjust and be flexible. If we have a large order, we will purchase a new press or hire another employee to make it happen. We're happy that the studio contains the growth of our business. We don't intend to add on to our studio space, so our growth is now limited to the space that we have.

How did you stay focused and original when you were starting out?

My goal was to simply create a product line that utilized processes that I didn't see present in the wholesale stationery market. As for style, I was simply trying to make objects that I loved and felt like I wasn't seeing anywhere else.

Do you identify more as an entrepreneur or a working artist?

I would say I relate to both. As Moglea grows, I feel like I'm more of an artist, as I care less and less about pleasing the larger design audience and more about making things that I feel are interesting

and beautiful. There is still a side to me that really loves to figure out how to mass-produce these handmade creations and still make a profit. That is my entrepreneurial side coming through.

Did you read business books, learn from hands-on experience, or get another form of business advice?

It has been a blessing to have a business alongside our family farm business. We can share our experiences and grow together, even though our businesses are so different. Both my husband Chad's parents and my mother were business owners, so we've always had a network of support and advice. I haven't read any business books, but most everything I learned about running a wholesale business was through the Tradeshow Bootcamp workshops that Katie Hunt created and facilitates.

What have been the biggest hurdles to growing your business?

The biggest hurdle when I started was really trying to figure out where I fit in within the stationery market. It took a couple of years after college to sketch and paint and develop my personal style. I was terrified to launch anything until I felt completely confident in it. I didn't want to copy what was already out there.

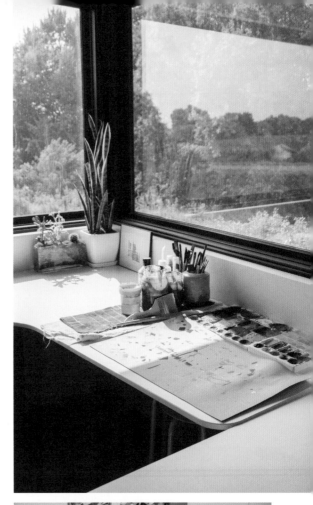

A DAY IN THE LIFE

I wake up to read or run a bit before our two
children wake up. Once they are awake, I help
our five-year-old son, Shepard, get ready
for school. Ev, our three-year-old daughter,
either gets ready for day care or ready to
come along with me to work, depending upon
the day. I get to Moglea around 9:00 a.m.
to meet up with the staff and help them with
whatever production projects they are work-
ing on. I answer emails or help manage pro-
duction until about noon or later every day. If
I have extra time outside of my management
duties, I'll work on designing new products
or ordering supplies in the afternoon. I leave
work at 5:00 p.m. every day to make dinner
and spend time with our kids. They go to bed
at 7:00 and at that time I'll either walk back
out to the studio to work until 11:00 or 12:00
or take the night off and hang out with Chad.

HAND-PAINTED
GIFT TAGS

These fun tags, in any shape, are sure to brighten up any package. They can also be used for Christmas ornaments for a fun addition to a tree.

SUPPLIES
- Paint (watercolor or acrylic)
- Jars or cups for holding paint
- Large paintbrushes
- Thick paper stock (chipboard, matboard, or watercolor paper)
- Scissors
- Hole punch
- Ribbon

DIRECTIONS
1. Pick out paint colors for your tags. It is easiest to pick out colors that complement each other. Try using just warm tones or cool tones or easy combos like navy and petal pink or an orangey red with a light blue.

(continued)

2. Once you have your paints selected, add to jars and thin them slightly with water so they are the right consistency. Acrylic paints work best when they are a melted ice-cream consistency. Watercolor paints work well when they are a milk consistency.

3. Using large brushes that will hold a lot of paint, paint your paper with large brushstrokes or make a pattern of your own.

4. Use your scissors to cut out your paper into unique tag shapes. This is the best part, because each tag will have a unique composition from your larger painting. Use the hole punch to place a hole where you want to thread your ribbon.

MAKE ME A MIXTAPE: INSPIRING SONGS FROM THE STUDIO

1. The Very Best, "Makes a King"
2. M83, "Midnight City"
3. Bruce Springsteen, "Badlands" (Everyone in the studio knows my love for the Boss!)
4. Daft Punk, "Doin' It Right"
5. Kanye West, "All of the Lights"
6. Coldplay, "Lovers in Japan"
7. On and On, "The Hunter"
8. The National, "This Is the Last Time"
9. Death Cab for Cutie, "Bixby Canyon Bridge"
10. Sufjan Stevens, "Get Real Get Right"

PAPER & CLAY

MEMPHIS, TENNESSEE

BRIT MCDANIEL
CERAMIC ARTIST

After graduating high school, Brit McDaniel moved around to different cities, taking classes here and there and eventually graduating from the University of Memphis with a BFA in 2013. She worked as a nanny for six years before she found herself living back in her hometown and figuring out what she wanted to do with her life. She found that her life path came in the form of Paper & Clay, a modern handmade ceramics studio located in Memphis, Tennessee, where she makes utilitarian ceramic pieces that are clean, modern, and suitable for everyday use.

"If I had to choose between running a small business and making work, I'd choose my work hands down. But I do think having an entrepreneurial mind-set is incredibly helpful." —Brit

A CONVERSATION WITH BRIT MCDANIEL

What keeps you going, gets you up in the morning, drives you to be a working creative?

I love my work. I think it's vital—I may have days where I'm frustrated or exhausted, days where I feel defeated, but I always come back from it. I love clay as a material, but I also love the process. I really enjoy the solitude of working in my studio. Slowly building a collection of pieces on my shelves, formulating recipes, and of course, that "Christmas morning" feeling when I open my kiln. I don't think that will ever go away.

How have you grown as a businessperson since starting to work for yourself?

Ha! Well, if I'm being really honest, I had no idea what I was doing when I got started. I've grown in so many ways—from the way I've planned my goals, to financial responsibility, to marketing my work, and everything in between. I think the most important part of my growth, as a creative professional, has been my ability to stay focused on my own work/life, etc., and to avoid being affected by things outside of my control. Of course, I still struggle with these things, but it's become much easier to deal with. I think it's something that goes hand in hand with ceramics, in a way. If you drop a mug you've just made on the floor—it's gone. Nothing you can do. I think clay pushes me to get over things quickly and move forward. Just make another mug.

In the world of Etsy and Pinterest, how do you remain original while still staying in line with your brand?

Creative work has been both complicated and glorified by digital media. On one hand, we have this incredible network of peers and customers that has never before been possible, but on the other hand it's become increasingly easy to copy or borrow too closely from other people's work. I firmly believe that artists need to steal ideas/techniques/etc. to grow and improve, but I think the trouble comes when creative professionals are simply copying work instead of stealing inspiration. If I see an idea that I'm drawn to, I try to either make it my own or make it better. If I can't do either of those things, I try to throw it out. I do subscribe to the idea of a collective unconscious (which I believe is stronger than ever thanks to social media and the Internet), and sometimes two or more people can come to a similar idea organically. When this happens it's a good test of your confidence in your own work, and it can often help show you areas that need improvement. I try hard not to take things personally and to move on quickly. I think this is really important in the creative field, and the better you are at responding to conflict or the unexpected in a positive or useful way, the better for the health of your brand (and your person). When it comes to staying fresh, I sort of turn the tables a bit. If I start to see a lot of work on Pinterest or Etsy that's similar to something I've made, I feel like that's an indication that it's time to push forward and evolve my work.

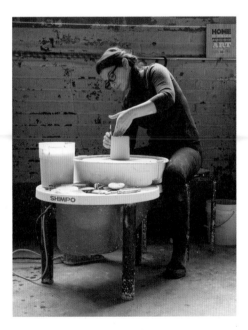

141

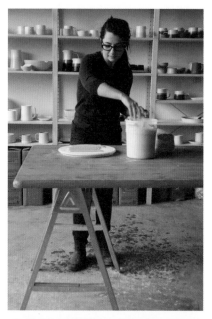

A DAY IN THE LIFE

In the cold months my day starts around 7:30 a.m. I generally glance at my email over coffee and respond to anything pressing, then I can get to the studio by 9:00. It takes me about an hour before I can get to work in my space. I set up my music or podcasts for the day, make another coffee, and address any pieces that were left drying from the day before. If there's any trimming or handling to be done I try to finish that before throwing new work. I try to do the big things (or scariest) on my list first, and then work my way down. I'm happiest in the studio when I can just make new work, so I try to allow a little time for that regularly.

I'll throw until about 5:00 or 6:00 p.m. and then finish any nearly complete pieces before covering the day's work. I usually leave the studio around 6:30 or 7:00, clean myself up, make dinner, and then relax with my little family. Two or three days a week I work late at home either answering emails, working on my website or Etsy, or packing/shipping orders.

SPRAY GLAZING WITHOUT AN AIR COMPRESSOR

This is a great technical shortcut for any ceramic artist who might not have all the tools built up yet or is just starting out. If you live somewhere that has a kiln you can use to fire your piece, you could make this at home, even if you aren't a ceramics artist, but have an unglazed piece of pottery.

SUPPLIES

- Bisque-fired piece of work
- Glaze(s) of your choice (thinned to the consistency of half-and-half)
- Paper tape (masking or washi) or stickers for creating your design
- Soft rubber rib (optional)
- Banding wheel
- Moist clay or sticky tack
- Funnel or small container with pour spout
- Preval spray system
- Safety mask
- Tweezers or needle tool
- 000 brush

(continued)

DIRECTIONS

1. Start by choosing a bisque-fired piece that you'd like to experiment on. Cylindrical pieces like cups, bowls, and vases work best. Pre-glaze the inside of your piece (if applicable) and allow to dry overnight if possible. Make sure your piece is free of dust and debris.

2. Apply your tape or stickers to create a pattern, design, or image. Carefully smooth down the tape or stickers with your fingers or a soft rubber rib to ensure clean lines.

3. Once your design is applied, center your piece on the banding wheel and secure the bottom of the pottery with a bit of moist clay or sticky tack.

4. Using a funnel or a small pouring container, fill the bottle of your Preval sprayer with glaze, paying attention to the fill mark. This is important, as the correct balance of liquid to air will make spraying much easier.

5. Attach the straw to the sprayer, then attach the bottle of glaze.

6. Put on your safety mask and, using a piece of paper or the inside of your sink, test the sprayer to get the hang of how to hold it. It may take a little practice to get the spray angle just right.

7. Once you feel comfortable, return to your piece and begin. Slowly spin your banding wheel and begin spraying, keeping the bottle at the appropriate angle, moving your entire arm up and down to evenly coat the piece. Work

in layers, allowing the glaze to dry a bit between turns on the banding wheel to avoid drips.

8. Once your piece is sufficiently coated, allow to rest 5 to 10 minutes, or until the glaze is dry to the touch.

9. Wash your hands to avoid transferring glaze to your piece, and then grab your tweezers or needle tool.

10. Begin peeling off your tape or stickers by inserting the tweezers under the edge of the sticker and lifting. Once you have a freed edge, use your fingers or tweezers to remove the sticker. Continue this until you have removed all of the stickers or tape. Do your best to remove carefully and cleanly, but don't worry about any glue residue that might be left behind, as this will burn off in your glaze firing. Touch up any rough edges with a 000 brush. Now you're ready to fire!

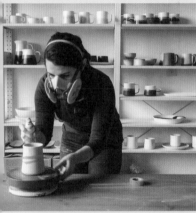

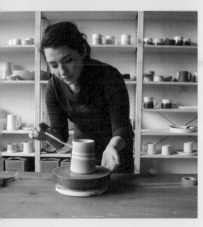

MAKE ME A MIXTAPE: INSPIRING SONGS FROM THE STUDIO

1. Neko Case, "Thrice All American"
2. Air, "Highschool Lover"
3. Télépopmusik, "Breathe"
4. Father John Misty, "Nancy from Now On"
5. First Aid Kit, "Emmylou"
6. Gillian Welch, "Everything Is Free"
7. Sia, "Elastic Heart"
8. Lana Del Rey (I know, I know), "Young and Beautiful"
9. Midlake, "Van Occupanther"
10. Sharon Van Etten, "We Are Fine"

QUILL & FOX

LAKE OSWEGO, OREGON

YAS IMAMURA
ILLUSTRATOR

With plans to go into marketing and economics after college, Yas Imamura never thought she'd start an art business. But when Yas took a job just after college as an art director for an advertising firm, she was inspired to go back to school for design. In her last year of design school, Yas decided to revisit her love of art and illustrating. Taking that turn paved the way for what we know today as Quill & Fox.

A CONVERSATION WITH YAS IMAMURA

What have been the biggest hurdles to growing your business?

Product development has been a challenge for me lately, as I look into expanding the line. I strive for a certain quality that is ethically made in the United States, but at a scale and cost that fit our small-sized business—something that doesn't always go together. What I'm learning is to take things slow and not to rush into things too much. Another thing is trade shows and having more in-person visibility. I'm a huge intro-vert (though I promise, I'm quite a func-tional and charming one!) and overcoming that anxiety has been hard for me.

What's most important to you when out-sourcing supplies for your products?

Minimums and pricing are always the first things I check. It's a good practice to always ask for samples. Sometimes it's easy to fall into complacency and assume since the early samples look great, that a slight vari-ation to the printing process or the material will just be as you expected. Most of the time it isn't. I try to be as transparent with my concerns and questions as possible.

What have been the biggest rewards of running your own business?

Keeping my business at a manageable size and not letting the pressure of the industry intimidate me really helps me a lot as an artist and as a business owner. It allows me

"I've always learned by doing, which isn't always an advis-able business strategy. But you learn to mitigate the risks by taking things slow, and not jumping into huge capital investments too quickly, until you learn the landscape of the market more." —Yas

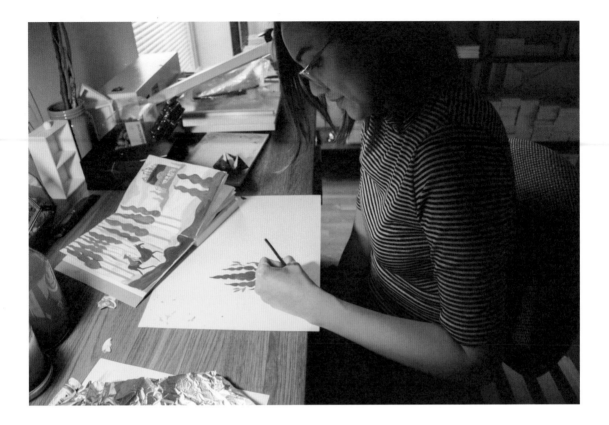

to venture into other creative projects not always related to Quill & Fox, but has a way of finding its way back to the work I've been doing for the shop, and invigorating the creativity further.

What do you find most inspiring about your space?

The privacy it gives me in my own little nook gets me inspired each time. That sense of peace. I especially love it at night, when everything else is quiet, with my husband working in the next room down the small hallway, and I'm left with just the light of my lamp for company.

How have you grown as a businessperson?

I've learned to put in more careful thought on how I position myself as a brand. The same way you get to know more about yourself every year, you develop a keener understanding of your brand as you move forward. It's a story constantly unfolding.

A DAY IN THE LIFE

I always start the day with my husband, Andrew, catching up with most of my emails. He's quite the early riser, so he sometimes takes care of more urgent ones for me. I get to work on shipping orders out from both our main retail site and our Etsy site. I check on our outstanding wholesale orders as well, and prep anything that needs to go out that day. At some point in the day, a yogurt cup finds its way into my hands, though I usually still trudge on with work, until a proper lunch that is more like an early dinner, at around 4:00 p.m. Some light snacking happens before 7:00 p.m. I need to be better at having regular meals. I do all my creative work at night. I just love, love making art at night.

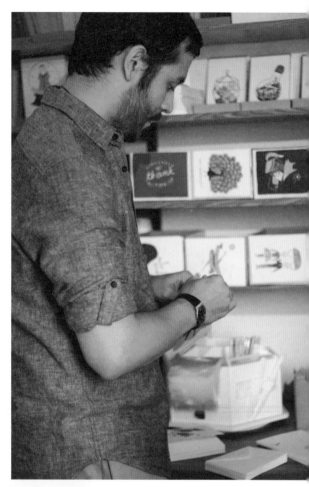

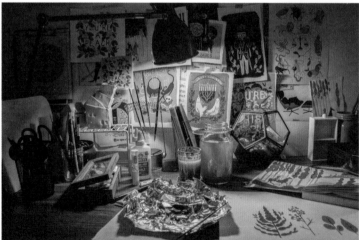

MAGNET PLANTER

Magnets don't need to be flat anymore. With this fun project, bring your fridge to life both with dimension and with a little greenery.

SUPPLIES
- Sculpey clay
- Modeling ball tool or any object you can use to mold the inside with
- Kitchen knife (optional)
- Baking sheet or tinfoil and oven
- Paint
- Paintbrush
- Magnet adhesive
- Small amount of potting soil
- Toothpick
- Plant trimmings

DIRECTIONS
1. If you're working with a clay that gets stickier as your hands get warmer, then be sure to start at a relatively cool room temperature or pop your clay in the fridge for a while, or whenever you need to.

2. Knead the clay on a flat surface to get rid of air bubbles.

3. There are hardly any limits to what kind of planter you'd want to create, as long as it's small enough (no bigger

(continued)

than 1½ in/4 cm in diameter) that it doesn't slip off your magnetic surface (unless you have very strong magnets) but deep enough to hold soil. You can do a nice cube to start with before molding the space in the middle with your ball tool. Hacking off corners from your cube with a kitchen knife can create a neat little geometric aesthetic. Whatever the design you create for your planter, it needs to have a flat back surface for the magnet to stick on.

4. If your clay got a little too soft from all that molding and heat, you can pop it in the freezer to stiffen a bit.

5. When you're satisfied with your design, lay it out on a baking sheet or tin foil to bake in the oven. Check the package of your clay for specific instructions.

6. Remove from the oven and, once it has cooled off, paint it. Let it dry, then apply the magnet adhesive.

7. Add soil, and poke a little hole in it with a toothpick to stick your plant in. A good choice would be succulents, as they are very easy to propagate with random trimmings and need very little water.

MAKE ME A MIXTAPE: INSPIRING SONGS FROM THE STUDIO

1. Shugo Tokumaru, "Linne"
2. The Staves, "The Motherlode"
3. Simon and Garfunkel, "April Come She Will"
4. The Staves, "Mexico"
5. The Staves, "I Try"
6. Karen O, "Strange Love"
7. Dr. Dog, "Jackie Wants a Black Eye"
8. Delta Spirit, "Parade"
9. Buffalo Springfield, "For What It's Worth"
10. Danna and DeVotchKa, "The Winner Is"

19

SCOUT BOOKS

PORTLAND, OREGON

LAURA *and* AUSTIN WHIPPLE
PRINTMAKERS

In 2000, Laura Brian was a Fulbright recipient and student studying the Arabic language, and Austin Whipple was a recent design school grad who ran a web design company and coedited a literary journal. In 2001, Laura began working on the journal that then led the two of them to develop a print studio space to continue to explore design and publishing. Their company, Scout Books, which creates customizable, 100 percent recycled paper–based books, grew from there. They also have a second business, producing silkscreen wooden signs through the name Outpost Sign Co.

"Follow our intuition. Consult the brand guidelines when in doubt." —Laura

A CONVERSATION WITH LAURA WHIPPLE

In the world of Etsy and Pinterest, how do you remain ahead of the game and original while still staying in line with your brand?

We don't actually sell on Etsy currently or actively Pin. It's difficult to stay inspired and true to yourself while paying attention to everyone else at the same time. It's important to be aware of what's happening, but seek your own inspirations offline. For us, it's really necessary to actively cultivate who we are as humans offline. We're inspired by the natural world, literature, buildings, family, friends, food, color, photography, music, outer space, etc. What's trending on Instagram is fleeting, so I need to tune it out to some degree to feel happy about my life. Being present feels increasingly difficult, so I'm working on that.

As your business expands, how do you decide which direction to grow in? Add more space or employees or products? What guides you?

We start with space. We've renovated two commercial buildings now, remodeled our home, and are hard at work on a third commercial building. Considered space to work and live in is the ultimate inspiration for us. After space, we focus on designing products and building the team that will bring the space and product manufacturing to life.

What do you find most inspiring about your space?

There's not a clear division between public and private, personal and commercial, and that is lovely, challenging, and ultimately a complete blessing. I adore that our offices are directly integrated with our Scout Books factory. The buildings hum with the energy of my coworkers and the machinery that we use every day to create thousands of Scout Books for people all over the world. It's incredible.

Where do you see your business in ten years?

In ten years, I'll be fifty and will have been self-employed for twenty-five years. That's half of my life! It'll be an awesome achievement. I love what we do at Scout Books and Outpost, so it's very satisfying to imagine the businesses thriving well into the future. Print has continued to reinvent itself in the digital era, and our print-centric business is no exception. I know the power of connecting through the Internet will remain critical to the growth of Scout Books, so I anticipate we will be integrating more online features over the next years, with the goal of connecting the undeniable power and simplicity of paper-based communication tools seamlessly with people's everyday lives. It's quite challenging to know what the next decade will bring on a macro level; climate change weighs heavily on my mind, as does the increasing income disparity that we see in our own country and around the globe. I hope our company can contribute in meaningful ways to solutions to these

very real and large problems. On a micro level, I am confident that Scout Books will have evolved into an even better version of its already radical self. I look forward to seeing how our clients grow and how my colleagues grow, too. On a personal level, I would love to be writing more, learning new languages again, and living some of the year in a rural setting.

A DAY IN THE LIFE

I try to wake up at 5:30 a.m. I usually let our chickens out so they won't wake the rest of the family. I feed our dog, Sunday, and two cats, Mimi and Grace. Then I head to my exercise class. It's basically an obstacle course for grown-ups that changes every day. I've been doing it now for several months and really like how both challenging and exhilarating it is. The best part is that I'm back by 6:45 a.m., and can eat breakfast with my family, and then we walk with our girls to their elementary school a few blocks away to drop them off, and then it's time for us to head to work. Our workdays really vary, so we just go with what happens. After a busy workday, I leave to pick up my girls at school. We play at the playground and then meet friends at the ice cream shop. Then dinner and hang-out time with our little ladies.

DESIGN-IT-YOURSELF NOTEBOOKS

These DIY Scout Books with unprinted covers are easy to work with and the perfect canvas for illustrating, stamping, and stenciling on, or for making a one-of-a-kind notebook.

SUPPLIES

- DIY Scout Books
- Solid-color Scout Books
- Sakura Pen-Touch paint markers
- Sakura Gelly Roll pens
- X-ACTO knife
- Cutting mat
- Scotch tape
- Paper
- Gouache or acrylic paints
- Paintbrushes
- Palette
- Small dish for water
- Glue stick

(continued)

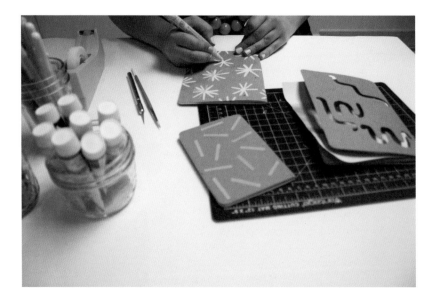

DIRECTIONS

1. Start with the blank-cover DIY Scout Books and brightly printed solid-color Scout Books.

2. Sakura's Pen-Touch paint markers and Gelly Roll pens are perfect for drawing on Scout Books covers, and make for bright opaque shapes. Create your own geometric patterns and experiment with shape, repetition, and color. Try layering different shapes, line, and color—be bold!

3. Add another layer of depth to your design by cutting shapes into the cover using the X-ACTO knife and cutting mat. Use Scotch tape to tack the cover down to the mat so that it doesn't slide around while you cut.

4. Cut an additional piece of paper to fit behind the front cover of the Scout Book, and then paint a gradient or any other design onto the paper, and allow to dry.

5. Open the cut Scout Book and apply the glue stick to the inside cover, then affix your painted sheet to the inside cover, painted-side out.

6. Close your Scout Book and put a heavy book on top to weight it down and flatten while it dries for 10 minutes.

MAKE ME A MIXTAPE: INSPIRING SONGS FROM THE STUDIO

1. Nite Jewel, "One Second of Love"
2. Laura Welsh, "Cold Front"
3. Emma Louise, "Pontoon"
4. Joan as Police Woman, "The Magic"
5. Yelle, "Bouquet Final"
6. MNDR, "Feed Me Diamonds"
7. Class Actress, "High on Love"
8. Abbe May, "T.R.O.U.B.L.E."
9. El Perro Del Mar, "Change of Heart"
10. Etiquette, "Pleasantries"

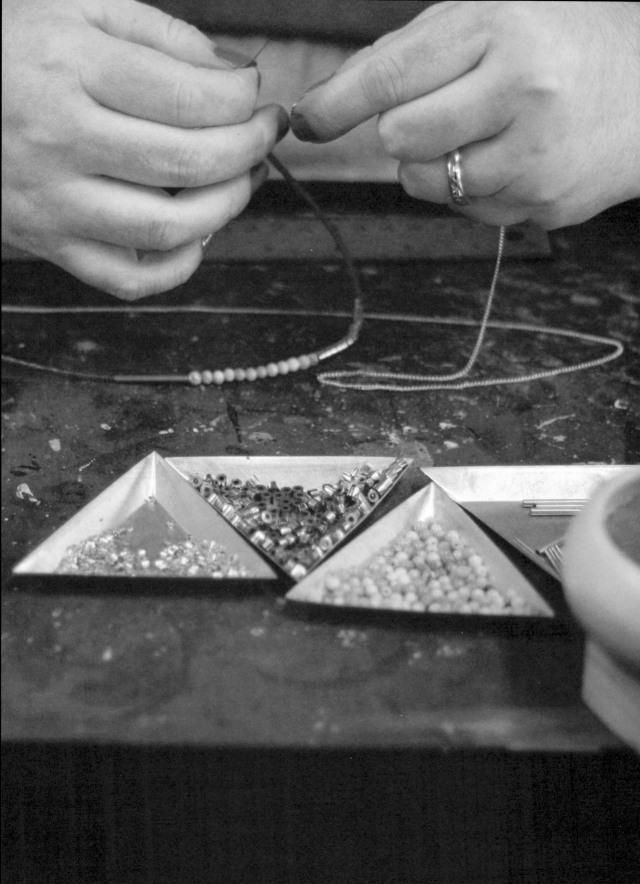

SON OF A SAILOR

AUSTIN, TEXAS

WILLIAM KNOPP *and* JESSICA TATA
JEWELRY DESIGNERS

When Jessica Tata and William Knopp met, she was working her dream job in San Francisco and he was in the oil fields of Texas. After a ten-month long-distance relationship, Jessica was feeling the tug to return home to Austin. Once they were in the same city, they combined her degree in photojournalism and his degree in illustration and graphic design, and Son of a Sailor was formed. It's not surprising that their attention to detail is what has driven Son of a Sailor Jewelry and Goods to almost name-brand status in a few short years. What started as a couple working together on their craft is now a multi-person business, a storefront, and collaboration work with some of the leading retailers in today's market.

A CONVERSATION WITH JESSICA TATA

What have been the biggest hurdles to growing your business?

As a couple that works together in a business that began in our home, I think that our biggest hurdle is separating our work from the rest of our life. We both love our jobs and are thrilled that we get to earn a living creating things with the person that we love, and that makes it hard to step away. It's easy to succumb to the stresses of owning your own business, especially when that business is always around you. So we work very hard to take time for ourselves, and not talk about the business right before bed and right when we wake up. But it's very difficult! That, and accounting. I really thought I was better at it than I actually am! So, for me, hiring a bookkeeper was the best thing we've done for the administrative side of our business.

The idea that we're designing things together that people like enough to buy, on a scale that allows us to be a sustainable business, is really amazing. The idea that we get to do all of this with the person we love is downright mind-blowing! I don't think we could ask for much more."
—Jessica

How did you stay focused and original when you were starting out?

I feel like we didn't have to try too hard to stay focused when we first began our business. We were (and still are) so thrilled at the notion of working creatively together as a job that staying focused was easy. In terms of being original, we took many steps to ensure that the items we were putting out into the world were as unique as possible. After we've settled on our designs and fine-tuned the items we've created together, we still make a routine out of doing research

to ensure that it's not already out there. If we're introducing an item that may exist in some form in the world already, it's because we're putting our own spin on it that is true to our brand and representative of our aesthetic.

As your business expands, how do you decide which direction to grow in? Add more space or employees or products? What guides you?

It's really instinctual for us. I am the more impulsive and fast-moving part of Son of a Sailor, and Billy is the more thoughtful and methodical one. I think that the pace at which we move when I'm pushing forward and he's moving more cautiously seems to result in a speed that is just right for our business. Additionally, we both find it to be very important to trust the universe when opportunities are presented to us. There are leaps of faith happening all of the time at Son of a Sailor! We truly believe that when momentum is created, you have to jump in and keep it going!

How have you grown as businesspeople?

Attending wholesale trade shows, negotiating deals with large corporations, and dealing with some of the pitfalls and perils that those things come with have strengthened us as businesspeople quite a bit. We know more about what our time and energy and ideas are worth, and how to defend those against exploitation and undervaluing. By necessity we have begun learning about our rights as creative businesspeople and how to approach legal issues. We continue

to learn more about financial planning and taking on risk as a business, and are beginning to move toward more comprehensive planning for the future of our company. All of these things come along with the growth of a small business. If you're paying attention, you can't help but learn so much along the way!

A DAY IN THE LIFE

I wake up, do the dishes, and make coffee. I roust William out of bed, and we get ready for work. We run late, mostly because we're simultaneously trying to pack lunch, feed the dogs, and pack the tools we brought with us the night before and all of the junk we inevitably have to bring from the house to the studio. When we get there, we chat with our staff for a bit, maybe eat a breakfast taco, and get settled in for the day. Then, it's a whirlwind of email, production, planning, packing, talking to folks who come into the studio, and more coffee! We're always seeming to leave the studio later than we anticipated because we're just trying to "finish this one last thing," and then we head home for the night. William is a great cook, so if we haven't left the studio too late he and/or I will make some dinner and catch up on our stories! Normal days involve a bit more talk about work, or William jumping on his creative peak around 10:00 p.m. to draw! We try to cram in some yoga or a workout, the occasional dinner and a movie, and hangouts with friends as often as we can, as well.

HAND-CUT LEATHER COIN PURSE

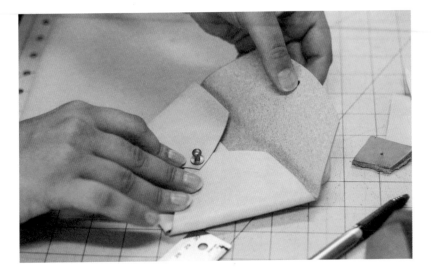

This simple and quick lesson in leatherwork is fun and makes for an unusual design.

SUPPLIES

- 9½-in/24-cm square of leather, preferably medium weight (not too floppy, but not extremely thick)
- Pencil
- Ruler
- Compass
- Rotary cutter, box cutter, and/or heavy-duty craft knife
- Computer and printer
- Rotary hole punch
- Spray bottle with water
- Leather paint or dye (optional)
- Finishing wax or leather sealant (optional)
- Clothespin or binder clip (optional)
- 1-by-6- or 8-mm brass button stud (make sure the screw of the button stud is long enough to go through three layers of the leather you've selected and still fasten to the button)
- Buttonhole punch (optional)

DIRECTIONS
Cutting Your Shape

1. Measure and mark the midpoint of your square of leather, and with your

(continued)

compass, draw a circle that is 9¼ in/ 23.5 cm in diameter on the unfinished side of the leather.

2. Cut out your circle using your tool of choice. In our experience, it is more difficult to get a clean edge with scissors than with a craft knife, but use what you have! Pro tip: There are tools made especially for cutting circles that have a blade on the end of a compass-style swivel—great if you work with circles a lot!

3. Print out the template from sonofasailor .co/diy. Lay the template on top of your circle, and mark the endpoints of the solid cut lines on the unfinished side of your leather. (The solid lines on the template indicate where to cut, and the dashed lines indicate where to fold.) Also mark the location of the circles, which indicate where you will later punch holes.

4. Using your ruler, draw your cut lines lightly with pencil on the unfinished side of the leather.

5. Using your craft knife, cut along the lines you just drew, removing triangular shapes from each side.

6. Next, use your leather punch to add holes to each flap.

7. The hole on flap A also has a small slit extending from it. This allows it to fit over the button stud and act as a closure. Take your craft knife and slice a ¼-in/6-mm line from the hole you've just punched. Alternatively, you can use a tool called a buttonhole punch to create the hole and slit in one step.

Finishing Your Leather

1. Using your spray bottle, mist the entire front and back of the leather piece

evenly. Don't saturate the leather fully, but coat the entire piece.

2. Fold each flap along the fold lines shown on the template, using your palm to press down and crease the fold as much as possible.

3. Once the leather has dried, take this opportunity to paint or dye your coin purse before assembly. Pro tip: Acrylic leather paints, water-based dyes, and leather stains are all exciting ways to add a pop of color or a beautiful tone to your coin purse. Sealing your leather with finishing wax or leather sealant helps protect against dirt and stains.

4. After the piece is treated as you wish, fold up flap C, fold in flaps B and D, and align the holes punched. You can use a clothespin or binder clip to help keep them together, if you like; just be sure you don't dent the leather!

5. Unscrew the button stud. You will have two parts: a screw portion that inserts into a button portion. Take the screw portion and insert through flaps C, B, and D from the inside of the pouch. The end of the screw will protrude just slightly through all three pieces and poke out on the finished side of the leather. Take the button portion and screw it onto the end of the screw, affixing all three flaps securely.

6. Tighten the screw on the button stud as much as possible.

7. Now your coin purse is assembled! Fold down flap A and push the hole with the slit over the button stud to close. (The closure will be very stiff at first—once you open and close your coin purse many times it will become easier. If it remains difficult to open, punch a slightly larger hole and/or extend the slit a bit to ease in opening.)

MAKE ME A MIXTAPE: INSPIRING SONGS FROM THE STUDIO

1. Buddy Holly, "Everyday"
2. Solange, "Losing You"
3. The Beach Boys, "God Only Knows"
4. Jan Hammer, "Crockett's Theme"
5. Hot Chip, "Flutes"
6. Sia, "Elastic Heart"
7. Presets, "Fall"
8. David Bowie, "Life on Mars?"
9. Van She, "Coconuts"
10. Irene Cara, "Breakdance"

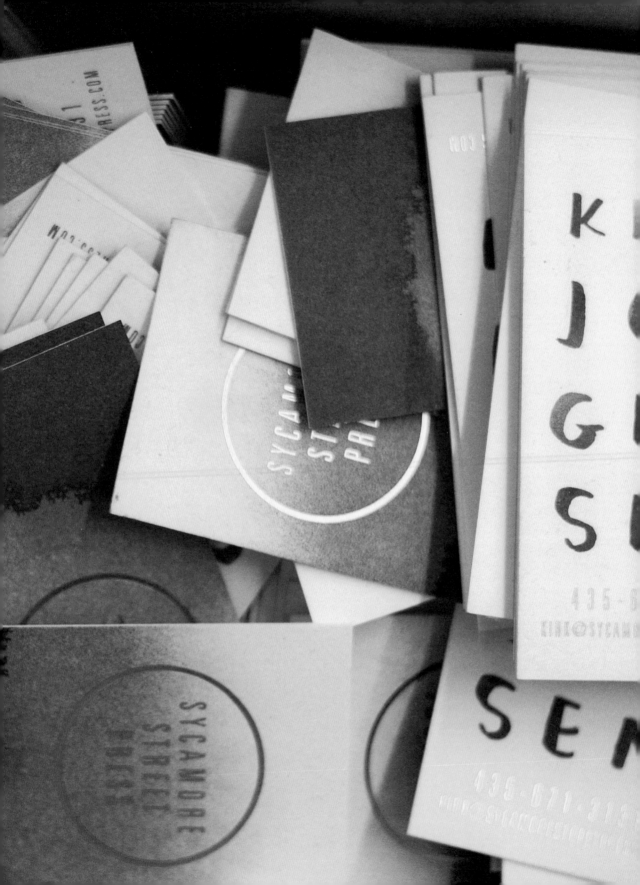

SYCAMORE STREET PRESS

HEBER CITY, UTAH

EVA *and* KIRK JORGENSEN
STATIONERY DESIGNERS

Husband-and-wife duo Eva and Kirk Jorgensen have paved the way in the world of paper for almost a decade. What started as a side business in 2007 quickly became a thriving family business and one of the leading independent stationery design companies in the country. Eva holds an MFA in fine art printmaking and with each new collection that Sycamore Street Press puts out, you can see the shift more and more clearly, from greeting card designer to thinking of each card design as a small piece of art. Kirk was working toward his PhD, after finishing his master's in Slavic linguistics, when he joined Eva, working full time at Sycamore Street Press.

"I come up with a phrase that I feel embodies our brand, and I hold everything that we do up to that phrase. I also try to ask myself when designing a product, writing a blog post, etc.: Is this something I would want to buy and/or Pin?" —Eva

A CONVERSATION WITH EVA JORGENSEN

Working for yourselves can sometimes be a really hard job. What keeps you going?

There have been times when we've questioned if this is the right path for us. But overwhelmingly, the feeling comes back that yes, it is. It's not a normal or expected path, especially in the small, traditional town where we live. But it allows Kirk and me to work together—both in the business and in raising our children. It allows us to live near our families. It allows us to be creative and do something we love while also putting food on the table. We feel incredibly blessed to have the life that we do.

Do you read business books, learn from hands-on experience, or is there another form of business advice that helps guide the business side of Sycamore Street Press?

My dad and other family members have given me some great advice over the years. I also love reading business books, something that I never would have guessed back when I was in college! I used to be afraid of imposing, but recently I've been more proactive about reaching out to peers for advice. Last year, I even started getting together on a regular basis with some friends who are also creative female entrepreneurs. Their support and ideas in helping move Sycamore Street Press forward have been priceless. But the majority of what we've learned has probably come through experience, the hard way.

Do you relate more as an entrepreneur or a working artist?

Although I am an artist, the way I tend to think of myself is as a creative who owns her own business.

I can see a lot of your personal style in your work. Tell us more about your interior design style.

In concept, it's simple and spotless. It's full of beautiful, practical, and quality items—antiques, vintage, and some new. It's eclectic, with a mix of influences from Scandinavia, France, California, Japan, and the mountains where we live. In reality, our home is a bit more dusty and cluttered than I'd like. It has an unending list of projects to complete. But it is cozy, welcoming, and comfortable, and that's the most important thing.

What would be a dream collaboration?

We have actually been able to do a dream collaboration with filmmaker Jenner Brown and stylist Meta Coleman. It all came together so quickly, and we worked together so well, that Meta, Jenner, Kirk, and I decided to form a film production company called NØRR. We've found that by working together, all of our work is elevated. Kirk and I never would have imagined that we'd be starting a second business, much less in the world of film. But it's one of those serendipitous opportunities that felt right and we couldn't pass up!

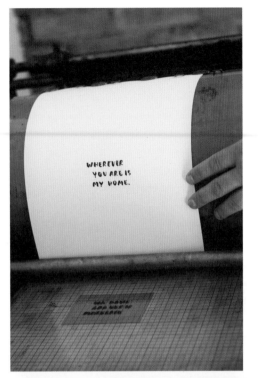

A DAY IN THE LIFE

Our daughter, Ingrid, crawls into bed with us first thing in the morning. I cuddle with her and try to go back to sleep while she watches a show on the iPad. Eventually, I drag myself out of bed and get the kids started with breakfast. (I have an autoimmune disease, and am still struggling with my energy levels. Because of that, I'm taking it a bit easy on myself so I can get my health under control.) The next hour or so is a madhouse as we scramble to get everyone fed, dressed, and ready to go. (Kirk and I each stay home with the kids one day a week, each of our mothers takes another day of the week, and they go to day care once a week.) We usually get to work around 9:30 and dive into the first task, which is usually something different every day! We try and take a quick lunch away from our desks, although that doesn't always happen. Then we plug away until about 5:00 p.m., when we join Ingrid and Lars and get dinner ready. We have dinner together as a family, and get the kids to bed at 7:00. Then we step back into our studio (we work from home) for another couple of hours. Sometimes we end up working late into the night, although we try to call it quits by 9:30 if possible. I need time to wind down in the evening or I can't sleep, so we spend the next couple of hours watching a show and reading. We normally turn the lights off around 11:30 or 12:00.

GIFT WRAP
ENVELOPE INSERTS

Sure, getting mail is fun, but it can be even more fun with this easy craft. Make any envelope fancy with this simple gift wrap insert for a standard-size envelope.

SUPPLIES
- Envelopes
- Scissors
- Card stock
- Pen or pencil
- Text-weight paper (we like using patterned gift wrap like our Indigo Spots design)
- Glue stick

DIRECTIONS
1. Carefully tear open an envelope along the seams.

2. Use scissors to cut along the inside edge of the glue on the envelope flap, down along the sides, and across the bottom of the envelope. This will be the shape of the final envelope insert.

(continued)

3. Test the shape you've just cut out by sliding it into another envelope. Make adjustments as necessary.

4. Once you are happy with the shape of the insert, trace it onto a piece of heavy card stock.

5. Cut the shape out of the card stock.

6. Test the card stock shape by slipping it into an envelope to make sure it still fits well. Make adjustments if necessary.

7. You now have a sturdy envelope insert mock-up that you can use to make many envelope inserts. Simply trace it onto the back of the paper you want to use, and cut the shape out.

8. Place an insert into an envelope and carefully get it into the correct place.

9. Fold the envelope flap down, keeping the insert in place. Be sure to press down on the envelope flap, creasing the insert in the process.

10. Carefully fold back the envelope flap, leaving the insert facing down.

11. Apply glue to the back of the two edges of the insert (the edges that come together like the point on a house).

12. Fold the envelope flap back down and press for several seconds. This will adhere it to the glue on the insert.

MAKE ME A MIXTAPE: INSPIRING SONGS FROM THE STUDIO

1. The Cure, "Just Like Heaven"
2. John Maus, "Believer"
3. The Beach Boys, "Don't Worry Baby"
4. We Are Serenades, "Come Home"
5. The Kinks, "Waterloo Sunset"
6. Fleetwood Mac, "Dreams"
7. Belle and Sebastian, "Get Me Away from Here, I'm Dying"
8. Elliott Smith, "Say Yes"
9. Blouse, "Into Black"
10. Françoise Hardy, "Voilà"

TERANISHI STUDIO

SANTA ANA, CALIFORNIA

TEPPEI TERANISHI
LEATHER GOODS DESIGNER

Before moving to Santa Ana, where he now lives with his wife and three boys, Teppei Teranishi spent years touring with his band Thrice. He used the downtime on the road to create Teranishi Studio. Completely self-taught, Teppei has built one of the most unique leather brands. While music and touring are still a major part of his life, watching his brand grow to what it is today, that's "the good stuff," Teppei says.

A CONVERSATION WITH TEPPEI TERANISHI

What is your background?

I guess the gist of it is: I grew up in Southern California. I got super heavy into skateboarding around junior high and it took over my life. I discovered punk through skateboarding, which ended up shaping what I listened to all through high school and led to me starting a garage band with a few of my friends who had similar taste in music. That band is still playing and has been my career for a long time now. I started leather crafting as something to do to keep myself productive while on the road. It was something that could be done entirely by hand with a minimal amount of tools that I could bring along with me. The hobby basically snowballed into what is now Teranishi Studio. Thrice took a three-year hiatus and instead of staying in music, I decided to take the opportunity to try something completely different.

What have been the biggest hurdles to growing your business?

Ugh, what hasn't been a hurdle? I guess mostly inexperience. I dove headfirst into a world I knew nothing about and had no prior experience with. The learning curve was steep (still is!) and I've mostly learned by trial and error. Lots of learning from mistakes and taking things one step at a time. I'm still learning every single day and have so much more to learn; it's rather daunting to think too much about it!

"I'm always trying to find something new to do—a new way of doing something or combining different elements that I haven't seen done before." —Teppei

What keeps you going?

I enjoy it. It's challenging, it's fun, it's all the good stuff. Being able to create. The process of dreaming something up, going through all the steps it takes to make it a reality, and seeing the finished product in front of you is always so gratifying. It's just the icing on the cake when other people latch on to it and decide it's something worth spending their hard-earned money on. I'd also say being able to work and collaborate with others. I've been able to work with and learn so much from a handful of good people in my time doing this.

Did you read business books, learn from hands-on experience, or get another form of business advice?

I totally learned by immersion. I'm not a businessman at all and so the business part is the hardest for me. I'm learning slowly via lots of mistakes and hard lessons.

As your business expands, how do you decide which direction to grow in? Add more space or employees or products? What guides you?

I definitely struggle with this. I'm lucky to have always had great people working alongside me. I have a super solid crew of two other guys right now and we bounce ideas all the time.

A DAY IN THE LIFE

Wake up, get my kids' "snack," which is basically a breakfast pre-game. Make myself a coffee (usually Ethiopian brewed in a V60). Let the chickens out if they haven't been yet. Make some sort of egg concoction: usually simple fried eggs, or an omelet if I'm feeling adventurous. Eat, chill with the family for a bit, then head to the studio. Tackle some admin/computer work. Then make stuff! Lunch, catching up on my skate clips (usually via Thrasher.com). Coffee again. Make more stuff! Go home around 5:00 or 6:00 p.m. Dinner. Get wild with the kids. Read them a book, put them to sleep. Probably go work on a motorcycle in the garage or just chill with my wife and then snooooooooze.

HAND STITCH LEATHER TUTORIAL

If you are just getting started on making your own leather goods, this is a great tutorial on how to make great-looking hand stitches before you have the machinery to work on leather.

SUPPLIES

- X-ACTO knife
- Self-healing mat or cutting board: Basically something to cut and punch the leather on
- Leather: Something with a firm temper might be easier to work with at first so it's not flopping around—natural veg tan (aka carving or tooling leather) in anywhere from 3 to 5 ounces would be good
- Stitch groover (optional): This is to mark your stitch line an even distance from the leather edge; dividers or a compass could work as well
- Leather contact cement
- Stitching punch (Alternatively, you can use an awl to punch the stitch holes, but the process is a little more involved, so for the sake of brevity, we'll just go over stitching punches)

(continued)

- Mallet
- Scissors
- Waxed thread
- 2 heavy-gauge leather hand-stitching needles
- Stitching pony: You'll need something to hold the work for you so you have two free hands (you can improvise and squeak by at first: bench vise, knees, etc.)

DIRECTIONS

1. With the X-ACTO knife on the cutting mat, cut two small pieces of leather—maybe something like 5 by 2½ in/12 by 6 cm.

2. Mark a line about ⅛ in/4 mm on one of the long edges of the leather using your stitch groover.

3. Apply a light strip of contact cement on the underside of the edge to be stitched on both pieces of leather. Wait until the cement is tacky to the touch, carefully line up the edges, and press together.

4. Punch the stitching holes. Lay your piece on the cutting mat and, holding the punch as perpendicular as possible to the leather, punch through both layers, being sure to keep the punch perpendicular as you're striking with the mallet. Pay attention to how it's exiting the other side; you want both front and back to be an even distance from the edge. Congrats, your leather is now ready to stitch! Now on to prepping the needle and thread.

5. Cut a length of thread three to four times the length of the edge you're stitching.

6. Thread the needle, pulling about 2 in/5 cm of thread through the eye. Where the point of the needle meets the longer end, pierce a hole in the thread. Pull the needle all the way through the

pierced hole, until the longer length of thread is locked around the shorter length you initially pulled through the eye of the needle. Twist the thread ends together. Repeat on the other end of the thread with the remaining needle.

7. Pass one needle through the first hole in the leather and the thread.

8. Begin stitching with your stitching pony, if you have one (or improvise). There are several techniques to stitching, but I'll cover the one that seems the easiest to explain (this is also how I personally stitch). Insert both needles partway into the next hole (some people stitch toward themselves, some people stitch away; there is no wrong or right way). Take note of which needle is lying in front and which is lying behind. It's crucial (aesthetically) for this to be consistent with every stitch.

9. Continue to push the needles through. You may need to push them in sort of an *X* so as to not poke your fingers. Pull the thread all the way through until you've got a nice, snug stitch. You'll see if you're putting too much tension on your stitches if your leather starts to pucker between the stitches.

10. Repeat. Repeat. Repeat.

11. Backtack two or three stitches at the end, trim the thread as close as possible, and you're done.

12. Admire your handiwork and get stoked.

(continued)

SOME NOTES ON STITCHING

Aesthetically, you'll want your stitches to have a slight slant to them and you'll want this slant to be as even as possible on the front AND the back. The back of the stitches is very often overlooked. Yes, the front can look nice and clean while the back can look like a mess. It may take some experimenting, but try different things until you get your stitches right: different order of which needle goes in front and back, different ways of pulling the thread through, etc. To be completely honest, it seems to be different for everyone, and I can't really make heads or tails of it. What might work for one person might not work the same for the next. Play around until you find your mojo, and then stick with it. Whatever works for you, it's important that you are consistent with your movements for every stitch.

For the most part, even if your stitches don't look super clean, functionally, they'll be just fine.

MAKE ME A MIXTAPE: INSPIRING SONGS FROM THE STUDIO

1. Miles Davis, "Kind of Blue"
2. Beck, "Morning Phase"
3. Wilco, "Sky Blue Sky"
4. Talk Talk, the whole album, *Laughing Stock*
5. De La Soul, "Stakes Is High"
6. Faces on Film, "Elite Lines"
7. Ramones, "I Wanted Everything"
8. The Beatles, "Every Little Thing"
9. Don Covay, "Mercy, Mercy"
10. The War on Drugs, "Lost in the Dream"

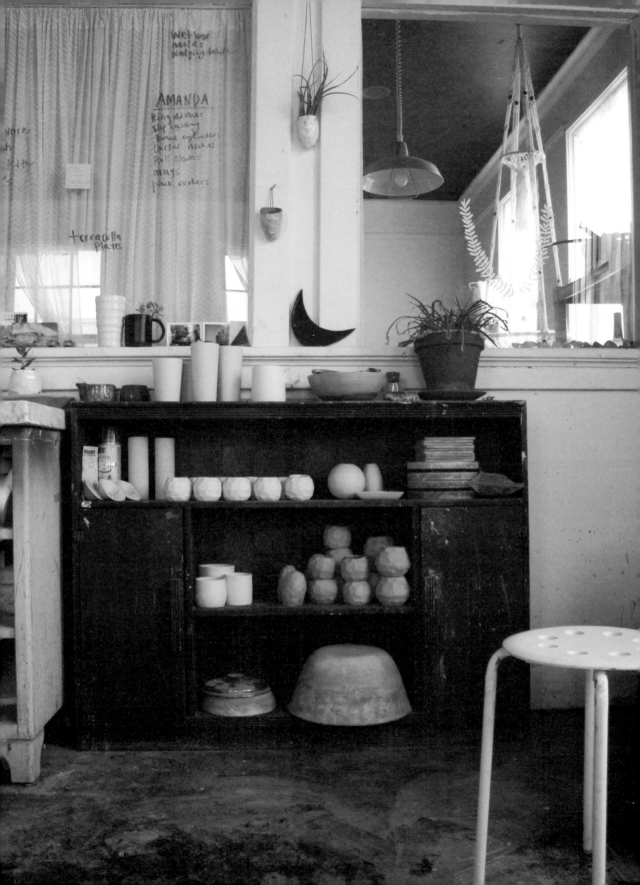

THE OBJECT ENTHUSIAST

KANSAS CITY, MISSOURI

EMILY REINHARDT
CERAMIC ARTIST

While getting her BFA in photography from Kansas State University in 2010, Emily Reinhardt's encouraging teachers nudged her toward majoring in ceramics. After college, she jumped into the workforce, taking a full-time job in the marketing department of a credit union. She applied her marketing experience to her business, which allowed her to create one of the most original voices in ceramics today at her company, The Object Enthusiast.

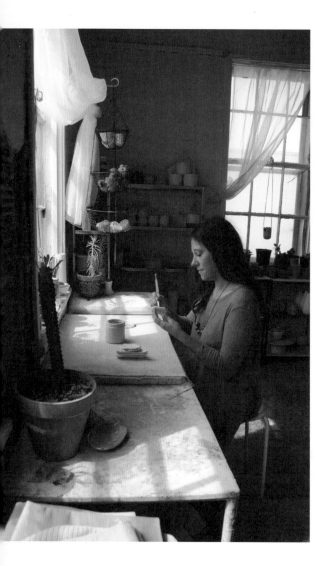

"I try not to use pottery to inspire my pottery. I'd rather discover my ideas organically through the other places that inspire and interest me."
—*Emily*

A CONVERSATION WITH EMILY REINHARDT

What have been the biggest hurdles to growing your business?

Definitely the business side of things. I never meant to start my business, so the back-end stuff—the bookkeeping, the accounting, the contracts, copyright applications—it's all really confusing. Staying organized has been a struggle my entire life, so the stakes seem higher when it comes to keeping a business organized. I'm always trying to improve in those areas, or hire help when I can.

What have been your biggest rewards to being a working creative?

The best reward is getting to wake up and do this thing that I love. I have so much more confidence in myself as a person since creating my business. I grew up considering myself to be pretty average, and I wasn't the most confident. Growing a business from the ground up has given me the courage to start to become one of my own biggest fans. I'm proud of that.

What keeps you going, making, creating? Wanting to stay in business for yourself?

The thing that keeps me in a forward motion is just staying true to the work I want to make. I have so many ideas in my head that I haven't had time to create in the real world yet. So whenever I'm feeling stuck, I try to spend an hour making one of those ideas that has been waiting for attention. It

usually informs a different project, or gets me more motivated to finish something I've been procrastinating on. I can't let those ideas be forgotten, so I'm often motivated to try to get one out. There's always a fear of failure in the back of my head, so I catch myself working like crazy once in a while.

What tips do you have for remaining original while still staying true to your brand?

I work hard to make things I want to live with. Some days the ideas come easier than others. I try making objects that can be used and enjoyed on a daily basis, while still being an heirloom or a keepsake. I used to dream of being an interior designer, so I often look to interiors to inspire my ceramics. I'm also very interested in floral design, so a lot of times I'm discovering and researching flowers and the professionals who know a lot about flowers. I try not to use pottery to inspire my pottery. I'd rather discover my ideas organically through the other places that inspire and interest me. I give myself time to be "off" if I need it, and I do whatever I can to make sure I'm fostering creative growth in my work. Sometimes it's easy, sometimes it's harder to work through, but I think I've started to develop my voice in my work. It's become easier to determine what is "on brand" for me these days. I follow my mission statement pretty closely. I strive to put good and thoughtful work into the world. Simple as that. I work really hard to make sure that the things I'm creating and sharing with the world line up directly with my wishes and dreams for The Object Enthusiast.

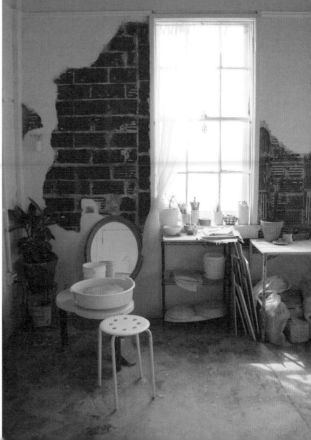

A DAY IN THE LIFE

I am usually a morning person. Coffee and breakfast are always essential! I usually walk the dog and am out the door by 8:30 or 9:00. I get to the studio and usually make it my mission to make as much as I can. Whether it's a wet clay day, or a glaze day, or a gold luster day, I'm usually there until about 4:45 so that I can make it to the post office by 5:00. I've been lucky enough to get to know my post office folks by name. They're awesome! Evenings are usually reserved for email, computer work, and cooking dinner. Sometimes I go back to the studio if I need to, but I try to get a few hours of relaxing in every night. I usually work seven days a week. Sometimes I'm afraid I'll feel burned out, but right now I love what I do and can't seem to sit still for too long on a day off. Sometimes my "days off" include going to the studio and just hanging out there without working. The great part about working in a cooperative workspace is that someone is always there! (Ready to have a beer or coffee, depending on the hour.)

MACRAMÉ PLANT HANGER

This is perfect for any stray ceramic vessel you might have lying around your house! It can be anything—a small crystal glass vessel, a hand-sculpted ceramic planter, whatever you have on hand. We'll make a simple hanger for the vessel using macramé cord and a few knots, and soon you'll have a perfect hanging vessel for a plant or flowers.

SUPPLIES
- Scissors
- Cord, leather, or string, strong enough to hold a vessel of some kind, but small enough to be tied into tight knots
- Vessel of choice
- Hook
- Plant or clipping

DIRECTIONS
1. Cut eight pieces of cord, each one the length of your arm.

2. At one end, tie all eight cords together in one big knot, about 4 in/10 cm from the end, and pull it really tight. You'll need the knot to

(continued)

support the entire weight of the vessel you chose, and perhaps a plant if you decide to plant something in it.

3. Section your cords into four sets of two and tie a knot in each set, approximately 2 in/5 cm from the main knot holding all the strands. Don't tie these knots too tight yet, as you'll want to adjust them later when you place your container in the middle.

4. Now, section these sets into new sets of two and loosely tie them in a knot. Again, you can tighten and adjust these knots later.

5. Repeat step 4 one more time for the third level of knots, keeping the spacing between each of the knots even.

6. The large knot will go on the bottom, so you can add your vessel and grab all the cords at the top. Now you can tighten and adjust your knots as needed.

7. Hold your cords straight and tie a knot at the top end, making sure that each set of cords is even and that the planter hangs straight, and tighten the top knot as hard as you can to keep it securely in place.

8. Find a hook and hang your planter in the windowsill or the ceiling, after making sure the hook is securely installed.

9. A cactus, succulent, air plant, or other small clipping would work beautifully and the sky is the limit with what kind of vessel you could use!

MAKE ME A MIXTAPE: INSPIRING SONGS FROM THE STUDIO

"I can't narrow it down to songs, so I'll pick the
ten artists that I play all the time." —Emily

1. Nina Simone
2. Future Islands
3. St Germain (Ludovic Navarre)
4. Paul McCartney
5. Daft Punk
6. Jim James
7. Rory Gallagher
8. T. Rex
9. Bonobo
10. Lou Reed

WALNUT ANIMAL SOCIETY

LOS ANGELES, CALIFORNIA

LAUREN BRADSHAW
DOLL MAKER

When Lauren Bradshaw was ten years old, she started sewing in an attempt to re-create her stuffed animals. This led to years of crafting and experimenting with new ways of making things. Knowing that she wanted to start her own business one day, she pursued a business degree with a focus on entrepreneurship in college. After launching a successful Etsy shop in 2007, Lauren started Walnut Animal Society in 2010. Her brand is focused on bringing smart business to whimsical creations.

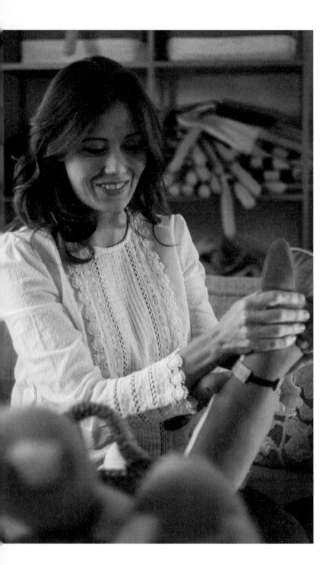

"I try to remember that the business idea came from me—and therefore it has to continue to come from me."
—*Lauren*

A CONVERSATION WITH LAUREN BRADSHAW

What have been the biggest hurdles to growing your business?

Before I launched, I researched methods of production that would allow me to scale my business. We established the business based on the knowledge that one day production would get simpler and I wouldn't be doing all of the work. But until we could afford the machinery and equipment, I had to do so much myself. Those were very long hours, and it was exhausting. We did finally get that equipment, which improved the process significantly. But then the challenge became handing off the work. I think it's normal for business owners to be perfectionists, and I certainly fit the bill. I still find it challenging not to control every single aspect of the animals that go out the door, but I have to let others help.

How have you grown as a businessperson?

I've found that my fear has decreased over time, as I've gained confidence in what I'm doing. I've learned to be comfortable with how I approach things, and that it's okay if I'm not rocketing to billionaire status after just a few years in business. Comparison can be helpful to an extent, but I've learned to stop doing it when it becomes harmful. I've also learned that when a problem seems huge, it's most likely not—there is a solution somewhere, somehow. So instead of focusing on how monumental the problem

seems, I try to get right to work on solving it before I let it overtake me.

Do you identify more as an entrepreneur or a working artist?

Definitely as an entrepreneur. I started Walnut to be a business, because I wanted a consistent income in a manner that I determined, motivated by being able to spend time with my family. I wanted to create a company I could have for the next twenty years, that was scalable and could grow into something way bigger than me. I've been a lifelong crafter, but I wanted to make something that I didn't have to do all myself from start to finish!

How did you stay focused and original when you were starting out?

Before I started, I did my market research. I found tons of children's boutiques and looked through their selection, and at that time (2010) I couldn't find a fox stuffed animal. I spent so much time online in the early days to be sure I had an idea worth making, and a gap in the market. From there, I spent time focusing on my sewing patterns and construction without spending a lot of time looking at what others were doing. This helped me stay focused. It took almost all of 2011 to get to a launching point, and when I finally launched in December, I felt really great about what I had spent the past year doing. It felt cohesive and charming, and I think it's because I focused on what was inside me rather than what was around me. It helped that each character had a set

personality, so I could stick to what they would choose to wear.

How do you stay true to your brand?

Very early on, when Walnut was just an idea, my husband and I sat down to plan out each character's personality. We have a pretty specific guideline for each animal so that when we make decisions about them, they are consistent with what that character would choose if he or she could. I'm so thankful for a talented friend who I hired to do all the branding for the site. That set the course for staying in line with a brand I felt really proud of. I made myself a mission statement of what I value, what I think my customers value, what I want to see, and what I'm proud of that I do. And that helps me stick to a plan when things can get so crazy, with life and with business.

A DAY IN THE LIFE

We usually go in our kids' room around
6:15 a.m. when they wake and they get out of
bed and play. My husband makes breakfast
and we all have tea. We get out the door
by 7:45 a.m. and my son Henry is off to
school until 3:00 p.m. This is the part that
is usually the same every day, and from here
it can change drastically. My husband, Joey,
works freelance mostly, so depending on his
schedule, either he goes to work or I do. We
take turns taking care of our youngest son,
Arlo. I work while Arlo naps and then if Joey
is off, he takes care of him while I work in the
afternoons. On a day where I'm working, I'll
start with emails, which helps me create my
task list for the day. This could include picking
out fabric for new samples, sketching out
clothing ideas, working on the book draft, or
thinking of entirely new products I want to
create. We use a sewing contractor here in
LA, and I go there frequently to drop off items
to be sewn. I also like to shop for fabric in
person rather than online, so I'll take time to
do that as well. I will also spend time finishing
animals; we stuff them all here and then sew
them closed, dress them up, and add their
letterpress tag. I like to handwrite a note with
each order, thanking the customer for his or
her purchase. I'll usually close the day with
a trip to the post office before coming back
together as a family for dinner. We sit at the
table together and eat, mostly entertained by
our chatty Henry. Hearing him talk and the
things that are inside of his brain constantly
amazes me and makes me laugh. We get
our two kiddos bathed after dinner, then split
duties; my husband, Joey, will read Henry a

book while I put Arlo down. After they're in
bed, I try and sit down to keep working on
some of the computer tasks from the day, like
social media. I like to get some uninterrupted
couch time in with my husband as well, so we
can chat about the day and feel connected.
Sometimes I'll need to keep working, but I
get too tired past 10:00 p.m. and start to get
grouchy, so I go to bed! There is no normal for
us, still, in our day-to-day freelance lives.

LAVENDER SACHET

This sachet is a sweet way to use small pieces of fabric that you may already have, and it's not a big, overwhelming sewing project.

SUPPLIES

- Scissors or rotary cutter
- Fabric
- Cutting mat and metal-edged ruler (optional)
- Straight pins
- Thread (one color for seam and another for topstitching)
- Sewing machine
- Chopstick, for pushing out corners
- Iron
- Dried lavender
- Small funnel or piece of paper rolled into a funnel shape

(continued)

DIRECTIONS

1. Cut two pieces of fabric 3 in/7.5 cm square. You can use a cutting mat and metal-edged ruler to make sure the corners line up to a perfect square.

2. Place the fabric right sides together and pin. Thread your sewing machine and sew around the perimeter using a ¼-in/6-mm seam allowance. Leave a 1-in/2.5-cm gap open for turning.

3. Turn the sachet right side out and push out the corners with a chopstick or similar tool. Iron.

4. Slowly pour in the lavender using the funnel, until the sachet is about half full.

5. Change the thread to topstitching thread, and lengthen the stitches on the machine settings for a nice finished look. Hold your sachet with the opening up, and gently shake to get all the lavender toward the bottom inside the pouch.

6. Use a ⅛-in/4-mm seam allowance for topstitching. Start first by closing the opening, tucking in the raw edges for a clean finish, and continue around the sachet. Before turning each corner, drop the needle and lift the presser foot so that you can shift the lavender away from the edge you are about to sew.

7. Trim the threads.

MAKE ME A MIXTAPE: INSPIRING SONGS FROM THE STUDIO

1. Florence + the Machine, "Shake It Out"
2. Bob Dylan, "Just Like a Woman"
3. MGMT, "Kids"
4. Cold War Kids, "First"
5. Jenny Lewis, "Just One of the Guys"
6. Gillian Welch, "Look at Miss Ohio"
7. Tom Petty, "Wildflowers"
8. Aimee Mann, "Deathly"
9. Fleetwood Mac, "Go Your Own Way"
10. Anything by my husband, Joey Bradshaw

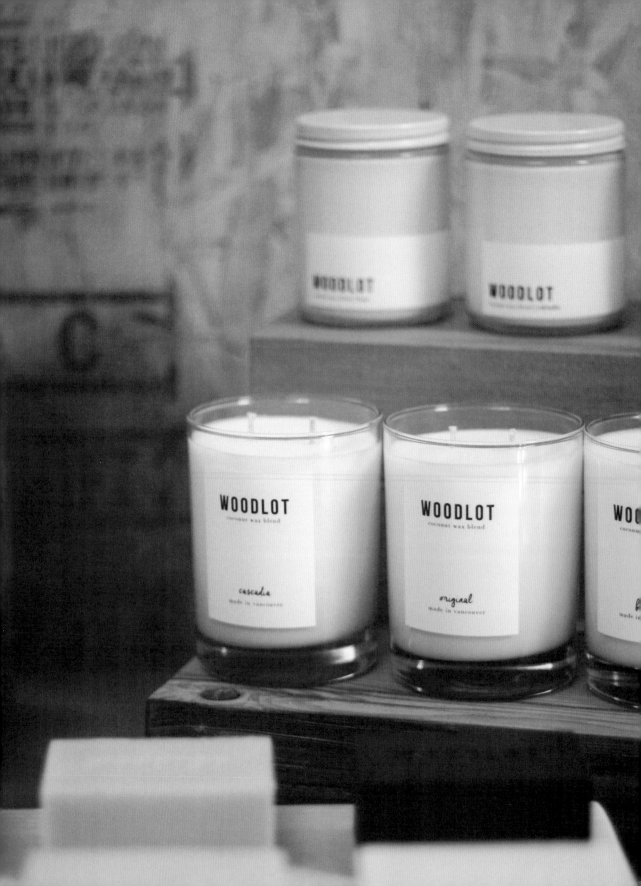

WOODLOT

VANCOUVER, BRITISH COLUMBIA

SONIA CHHINJI *and* FOUAD FARRAJ
CANDLE MAKERS

When Sonia Chhinji and Fouad Farraj started their toxin-free bath products company, Woodlot, in Vancouver, British Columbia, they were each in completely different fields. Sonia worked in marketing and communications, while Fouad was in the hospitality field. The timing of Woodlot couldn't have come at a better time for Sonia, who was not enjoying climbing the corporate ladder. It was that professional dissatisfaction that led them to found Woodlot in 2015, after they kept getting orders from friends and family after gifting them their homemade beauty products.

A CONVERSATION WITH SONIA CHHINJI

As your business expands, how do you decide which direction to grow in? Add more space or employees or products? What guides you?

We consider what's roadblocking us and try to figure out the best solution. We will discuss certain directions with mentors or other entrepreneurs. There's a lot we can learn by hearing the learnings of others who have done this before us.

What would be a dream collaboration?

Fouad and I both spent many years working in the hospitality industry. Collaborating with a well-known boutique hotel would be a dream. Seeing firsthand how amenities and service can really play into the enjoyment of a guest's stay is amazing, and something we'd be excited to be a part of.

How do you go about sourcing?

We focus on the integrity of the ingredient (plant versus fragrance, how it's produced), and then depending on the product we will focus on sourcing from growers, ethical trade, etc. We have plans on how we'd like all of this to look as we grow, but when you're a growing company you can be restrained due to lack of buying power and high costs.

"We have made some important decisions by allowing ourselves the time to study our data, and understand what our customer really wants." —Sonia

How did you stay focused and original when you were starting out?

From the beginning of our business, we set forth some metrics to focus on. We followed the data, from spreadsheets, when making some significant decisions, and this has helped us stay focused on our products and not get too caught up in things that are irrelevant. It helps us understand what our customer really wants. We have applied this approach with new product launches, scent applications, and packaging design. To be precise, we focus on three metrics: organic customer growth (online and offline), retention, and monetization.

What is some of the best advice you have received?

To take care of ourselves. Always make time to exercise and eat well. It's easy to put your business first and neglect yourself, but when your business is your baby, you need to take care of yourself to make sure you are giving your business everything it needs to thrive. This starts with a healthy and stable founder.

A DAY IN THE LIFE

Fouad and I are partners in life and business. It's not as sexy as bedroom to boardroom, but we do spend a lot of time together chatting about our baby (Woodlot) from the moment we wake up to the moment we rest our heads. We get that this isn't healthy but we're working on finding some balance. A typical day includes a healthy smoothie/breakfast, team sync up, identifying priorities, and getting to work. We're a small team and like to break bread together, sometimes daily, sometimes once a week. Lots of emails. Production. Coordinating wholesale and online orders. Putting together samples. We typically get up early enough to be able to respond to emails on the East Coast. But then we find ourselves on the couch catching up on admin into the wee hours. Due to logistical constraints, we can find ourselves spending most of our days at the studio working on something hands on, so those early and late hours really help a lot with productivity.

ESSENTIAL SALT SOAK

This quick and easy bath soak is great year-round and can be changed up with many different combinations of oils.

SUPPLIES
- Lavender oil
- Peppermint oil
- 1 cup Epsom salt
- 1 cup Himalayan pink salt
- 1 cup Dead Sea salt

DIRECTIONS
1. Mix salts together.
2. Add two drops of each oil into salt mixture.
3. Mix oil into salts.
4. Add ½ cup of mixture to bath water.
5. Enjoy a relaxing, soothing bath soak!

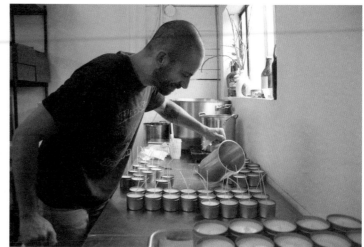

MAKE ME A MIXTAPE: INSPIRING SONGS FROM THE STUDIO

1. Avicii, "Wake Me Up"
2. A Tribe Called Quest, "Electric Relaxation"
3. Kid Cudi, "Pursuit of Happiness"
4. Jay-Z and Kanye West, "Lift Off"
5. Kanye West, "All of the Lights"
6. Q-Tip, "Breathe and Stop"
7. Rae Sremmurd, "No Flex Zone"
8. Rihanna, "What's My Name?"
9. J. Cole, "Land of the Snakes"
10. Frank Ocean, "Novacane"

ACKNOWLEDGMENTS

It's with great pleasure that I'd like to thank the handmade community, as a whole. That includes all the small shops that stock the work of these artists, the people who mentor and inspire them to create, the consumers who purchase handmade, and the large shops that also support the importance behind the working creatives. Thank you.

I would like to thank my agent, Kim Perel, who has believed in me from day one. Kate Woodrow, who made this book happen, and Rachel Hiles, as well as the entire Chronicle Books team—it's truly a dream come true to have the Chronicle glasses on the spine of this book. Rinne Allen, you are a blessing and I really appreciate all the help you've given me to make the photos look better than I could imagine. To all the artists in this book. Thank you for allowing me into your space, answering all of my questions, sharing honest conversation, and treating me so warmly. I would also like to thank Lisa Sheridan, Katherine Montague, Emily Mudd Blount, Jennifer Pierce Mathis, Rachel Atkins, Jason Mann, Kathryn York, Anna Avant, Coulter Fussell, Megan Patton, Jen Sperling, Kerri Sneed, Brandy Duffett, Sarah Fortune, Kathryn York, Shelby Kyser, Mike and Lauren Prater, Lauren Uncapher, James and Nikki Kelleway, Anh-Minh Le, Anne Sage, Grace Bonney, Meg Sutton, Kristen Ley, Amy Stringer-Mowat, Amy Richardson Golia, Elise Joseph, and Emily Blistein. These friends have been an endless pool of inspiration and support to me before *How to Make It* and throughout this writing process.

Lastly, I would like to thank all of my family and friends near and far and my Water Valley and Oxford communities, who have supported me writing this book, shopped in my store, come to one of my art shows, told me an idea of mine was a good one—all that encouragement resulted in my going for it. I couldn't do it without you.